IMAGES
of America

RMS QUEEN MARY

Once a year, the fashions of the *Queen Mary*'s heyday prevail when the Art Deco Society of Los Angeles hosts the Queen Mary Art Deco Festival in partnership with the ship. Art Deco enthusiasts from all over the world model their vintage finery during lectures, cocktail parties, and dances. All money raised goes to restore artwork aboard the ship. (Courtesy of Chris Launi.)

ON THE COVER: Most of the people packed tightly aboard the *Queen Mary* in June 1945, including officers, soldiers, seamen, flyers, and nurses, had marched silently onto blacked out ships to fight Hitler. After Germany surrendered, they returned joyously, welcomed by an exuberant display of lights, music, loved ones waving from the wharf, and an inexhaustible supply of milk, coffee, and doughnuts set out by the Red Cross emergency canteen. (Courtesy of the *Queen Mary* Archives.)

IMAGES
of America

RMS QUEEN MARY

Suzanne Tarbell Cooper, Frank Cooper,
Athene Mihalakis Kovacic, Don Lynch,
John Thomas, and the *Queen Mary* Archives

ARCADIA
PUBLISHING

ISBN 978-0-7385-8067-8

Published by Arcadia Publishing
Charleston SC, Chicago IL, Portsmouth NH, San Francisco CA

Printed in the United States of America

Library of Congress Control Number: 2009943321

For all general information contact Arcadia Publishing at:
Telephone 843-853-2070
Fax 843-853-0044
E-mail sales@arcadiapublishing.com
For customer service and orders:
Toll-Free 1-888-313-2665

Visit us on the Internet at www.arcadiapublishing.com

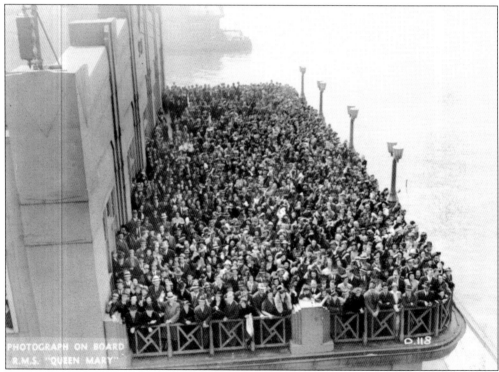

This crush of passengers in New York waits to board the *Queen Mary* on canvas-covered gangplanks corresponding to the three service classes. The designations, cabin, tourist, and third class, followed the naming standard set by the *Normandie* a year earlier. They were aimed at minimizing the differences between the levels of luxury and service in the public eye. After World War II, the cabin designation became first class; tourist became cabin; and third became tourist class.

CONTENTS

ACKNOWLEDGMENTS

The indefatigable Jacki Fanzo deserves our deepest gratitude for all her help with this book, but we appreciate even more what she has done for the ship. William Kayne ably assisted in allowing us to scan the photographs from the *Queen Mary* Archives. Without the City of Long Beach, the *Queen Mary* would no longer exist. We are grateful for its foresight. We also wish to thank Garrison Investment Group, Delaware North Company, Hostmark Management Group, Chuck Kovacic, Amy Ronnebeck Hall, and Logan Cooper, who has watched for ghosts on the *Queen Mary* since he was 3 years old.

All proceeds from this book will be donated to the *Queen Mary's* nonprofit foundation, earmarked for restoration of the artwork aboard the ship.

Unless otherwise noted, all images are courtesy of the *Queen Mary* Archives.

INTRODUCTION

May shipwreck and collision, fog and fire,
Rock, shoal and other evils of the sea,
Be kept from you; and may the heart's desire
Of those who speed your launching come to be.

—John Masefield
Poet Laureate of the United Kingdom, 1930–1967

When John Masefield composed this wish for a new ocean liner, no one could foresee the twists and turns fate had in store for Hull 534. Not that there were not already high expectations: Cunard White Star planned to make this hull into the largest, fastest, and most beautiful ship afloat. On September 26, 1934, a quarter-million Britons turned out in the pouring rain to watch as Queen Mary broke a bottle of Australian wine over the hull to christen the ship with her own name. Thus did the first Cunard ship named after a living queen slide majestically into the Clyde River as the RMS *Queen Mary*.

An army of people from around the globe made the ship what she was, from raw materials, to superstructure, to fitting out. Before her hull even began to take shape, she was a heroine for Great Britain. Her construction during the dark days of the Depression lifted the spirits of a beleaguered nation and gave paying jobs to untold thousands. Ironworkers built the enormous skeleton, which was filled with engines, boilers, and miles of pipes and wires. Kitchens and pantries were filled with the tools necessary to feed a multitude. Artists, designers, painters, and woodworkers made her public areas both elegant and comfortable. Bert Jones, the chief steward, claimed his slimness was due to walking around the models of staterooms being built on the dock and then roaming about the ship to see where they would be installed. Furniture was commissioned. Mattresses, china, tablecloths, and everything that needed to be built or purchased meant work—and a paycheck—for someone.

Even before she began her long and celebrated career, the *Queen Mary* captured the hearts and imagination of her countrymen. Her maiden voyage began on May 27, 1936, the day after her namesake celebrated her birthday. All the staterooms were filled, and eager would-be passengers had to wait for later voyages. Half a million people jammed the docks in drenching rain to celebrate. Whistles from smaller craft drowned out the strains of "Rule Britannia" as the magnificent new liner pulled out of the harbor to cross the Atlantic Ocean for the first time.

New Yorkers responded with giddy enthusiasm. Newspapers breathlessly recorded the *Queen Mary's* progress. Radio broadcasts kept enthralled listeners updated on her position and broadcast music being played aboard while passengers danced. A flotilla of smaller craft sailed to meet the ocean's new queen, and airplanes dipped their wings in greeting. Perhaps the only disappointment was that the *Queen Mary's* first voyage did not quite beat the *Normandie's* best time. The Blue Riband

for the fastest Atlantic crossing still lay in her future. Failure to break the speed record did not deter the merrymakers on the dock, nor, for that matter, the speechmakers. Perhaps one of the most delightful comments came from her first captain, Sir Edgar Britten, who said she was a wonderful ship to handle and then added, "But there is nothing really outstanding about her because everything is outstanding."

Upon her first arrival in New York, Cunard director Sir Percy Bates called the *Queen Mary* "a ship of peace," an ironic choice of words given Hitler's increasing profile. This optimistic pronouncement notwithstanding, the world was soon at war, and the *Queen Mary* would play a vital part. On her last prewar voyage in 1939, she arrived laden with gold and crammed with so many people fleeing Hitler's onslaught that beds were set up in the gym. Following this hair-raising transatlantic run, the *Queen Mary* slumbered in New York Harbor, while global tensions continued to rise, but soon time came for her to join the battle. Clad in dull gray, she quietly slipped out to sea to prepare for her work of ferrying soldiers over the ocean. Plotting a zigzag course and traveling without an escort, the *Queen Mary* eluded all torpedoes. Hitler offered a prize to anyone who could sink her, but no U-boat commander was able to claim it. The *Queen Mary* held a famous boast that she was never fired upon, nor did she ever fire a shot in anger.

By the end of World War II, the *Queen Mary*, with her sister ship, *Queen Elizabeth*, had carried more troops than any other ships, their graceful interiors and elegant furnishings carefully stored and replaced by the barest of necessities for troop transport. So many bunks lined the decks that they were likened to slave quarters. Even the swimming pool held tiers of bunks where men slept in shifts. The influx of men into the European Theater, made possible by the *Queen Mary's* participation, turned the tide of the war and contributed to an Allied victory. Her welcome in New York after Germany surrendered was even more raucous and joyous than the celebration that had greeted her on her maiden voyage. Troops arrived home in huge boatloads—tens of thousands at a time—and after the troops came home, their British war brides and children followed, getting their first glimpse of their new country from her open decks as the *Queen Mary* sailed past the Statue of Liberty into New York Harbor.

After the war, the *Queen Mary* resumed her rightful place as the standard for speed and opulence on the sea. And for a time she was unchallenged—her chief rival, the French SS *Normandie*, had met a tragic and suspicious end when she caught fire and sank while being fitted for battle in New York Harbor. The *Queen Mary*, however, burnished to her original glory and haloed by her wartime exploits, again became the ship of choice for movie stars, tycoons, politicians, and royalty. It was at this time that Cunard successfully purchased the stock necessary to remove White Star from its name and the company was once again known simply as Cunard.

From the moment she was launched, she was a metaphor for size. "Not quite as large as the *Queen Mary*," showed up in print nearly as often as Andy Warhol's "15 minutes of fame" quote does now. But even her many superlatives could not immunize her from the advances in technology and societal changes. And her chief rival would no longer be another grand ship of the line; it would be time, as represented by that most modern of conveyances, the airplane. People no longer thought of travel as an experience to be savored but as a necessity to be endured in the quest to move from one place to another. Speed and convenience trumped luxury, and the grand ocean liners could no longer compete.

In 1967, the *Queen Mary* made her gala final voyage around Cape Horn to her new home in Long Beach, California. The City of Long Beach had purchased her to use as a tourist attraction and hotel. Although the relationship has had its ups and downs, there is no doubt that without the vision of the City of Long Beach, there would be no RMS *Queen Mary*. With Masefield's "evils of the sea" behind her, she delights visitors with a glimpse into a bygone era. May she rock gently in her Long Beach berth forever. She is the last of her kind. Although there are still large ships, none will ever match the elegance of the great Art Deco ocean liners. God save the *Queen Mary*.

One

FITTING OUT
AND LAUNCH

In the early 1930s, the skeleton of a great ship rose slowly at the shipyard of John Brown and Company, Ltd., by Scotland's Clyde River. Hull 534 was of unprecedented size, but it was not until she was launched as the *Queen Mary* that analogies began in earnest. In *The Book of Comparisons*, her height was famously likened to Niagara Falls, and, it was reported breathlessly, her 10 million rivets could easily form a good-sized pyramid. At a length of 1,019.50 feet, she would have stood taller than the Eiffel Tower but not quite as tall as the Empire State Building. Postcards even showed her dwarfing Trafalgar Square, as if by some strange circumstance she should find herself landlocked in the middle of it. England's poet laureate John Masefield described, "a rampart of a ship, long as a street and lofty as a tower, ready to glide in thunder from the slip, and shear the sea with majesty of power." Britain's first superliner was being constructed.

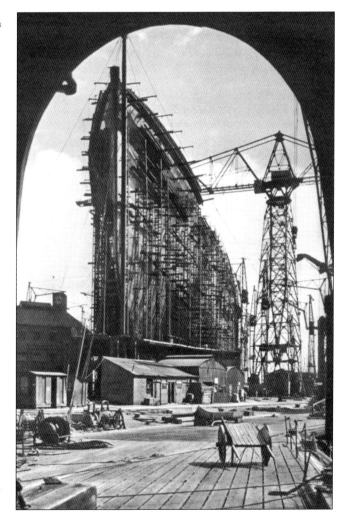

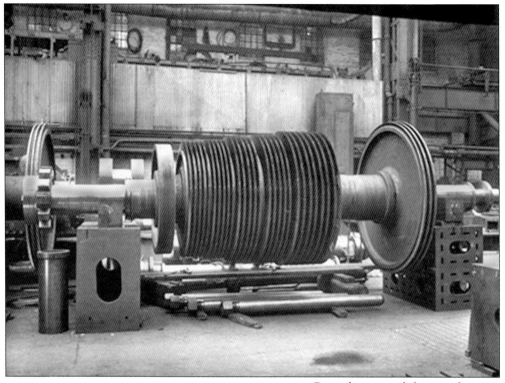

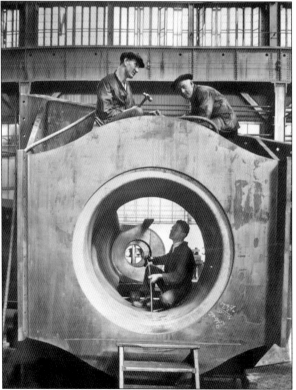

Cunard pioneered the use of turbine propulsion in ocean liners. The *Queen Mary* employed a system of high-, intermediate-, and low-pressure turbines for the most efficient use of the steam power generated by the boilers. This low-pressure turbine rotor weighed approximately 42 tons. Each rotor had to be carefully balanced to reduce vibration, which could be detrimental to the equipment and the ship's performance.

Castings, like everything else for the new Cunard liner, had to be of exceptional size. The castings made at Darlington Forge weighed a staggering 300 tons. The cast-steel stern frame was the largest ever made, dwarfing the men pictured with it in September 1931.

With Great Britain in the depths of the Depression, the *Queen Mary's* construction was a godsend for the John Brown Shipyard in Glasgow. More than 3,700 people worked directly on the building of the ship—many of them local men. Beyond the actual construction, however, the *Queen Mary* provided employment for another 10,000 people in Britain, producing hundreds of thousands of components, from brackets to textiles, from clocks to wood veneer.

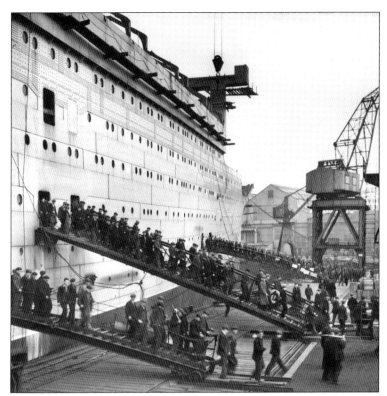

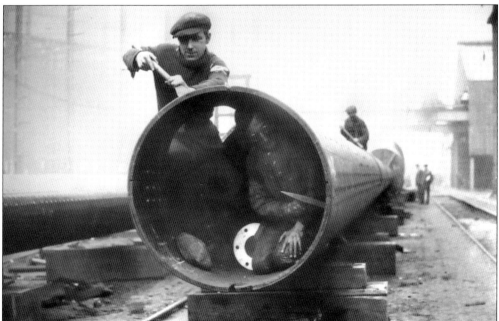

The masts of the *Queen Mary* were quite different from those of wooden sailing ships. The hollow steel shaft of the foremast was like a vertical tunnel, scaled by means of 110 steel steps inside. It led to the crow's nest, situated 130 feet above the waterline. Sailors ascending wooden masts had to worry about vertigo. Those on the *Queen Mary* may have added an element of claustrophobia.

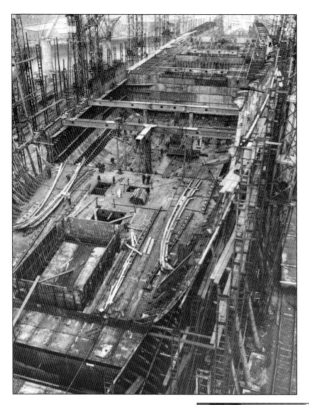

A bird's eye view shows decks under construction. The first rivet was driven by Donald Skiffington, the shipyard manager. Each rivet was hammered into place using "Thor" pneumatic riveting hammers. Accounts of the period note that if all the rivets used in construction were formed into a chain, it would reach from London to Newcastle, a distance of 270 miles.

The first class lounge measured 70-by-96 feet, with a height in the center of nearly 30 feet. The Glasgow workmen in the photograph are installing the parquet floor, made up of oak, mahogany, and Indian laurel. Except for periods of dancing, the beautiful flooring was covered with a selection of carpets and rugs in shades of dark green and gray.

With the center of the first class dining saloon extending up 27 feet in height, it was necessary to erect scaffolding in order for workmen to install inner sidelights of peach ripple glass mounted in silver-bronze metal frames. The ceiling was painted cream at the different levels, with a slightly more pink shade at the highest level. The soffits at the upper levels were veneered in Mazur birch.

Although the workmen in this photograph appear to be positioning a large vase in the first class main lounge, it is, in fact, one of the room's eight urn lighting fixtures. Constructed of bronze and golden onyx, they provided a warm glow that was augmented by 14 ceiling fixtures, with an additional 28 set into the frieze around the ceiling and 10 circular windows that could be illuminated at night.

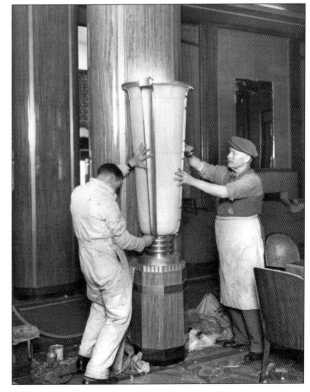

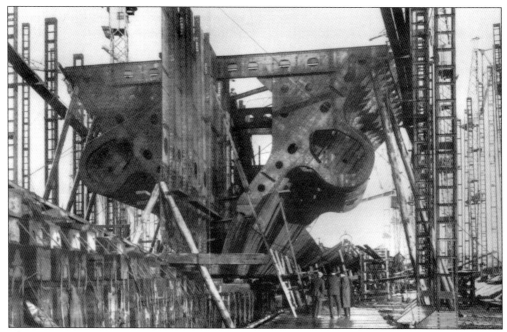

The *Queen Mary's* stern framing was cast in five sections with a total weight of 190 tons. Because of the *Queen Mary's* exceptional size, the usual conception of framing was deemed inadequate, and a much more closely spaced webbing was used toward the ends of the hull. The spine of the ship's skeleton was a 6-foot girder that ran the entire 1,019.50 feet of the ship.

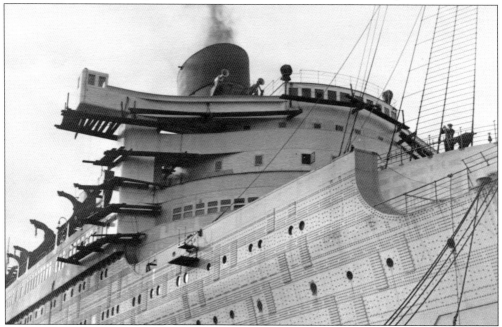

From the outside, the *Queen Mary* looked nearly finished as she sat for more than a year and a half at the fitting out basin. But unlike buildings, which are constructed from the ground up, ships are built from the outside in. Everything from enormous boilers and engines to light switches and ashtrays had to be brought onboard and fitted into place.

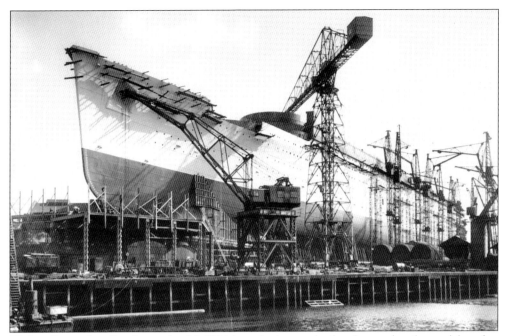

Within 18 months of her September 26, 1934, launch, thousands of workers and craftsmen labored to complete the masterpiece, inside and out. More than 735 miles of cable, four massive turbines—the heart of the greatest power plant afloat—a 35-ton propeller, forests of woods, and acres of textiles began to shape the heart and soul of the ship. This photograph is dated September 5, 1934.

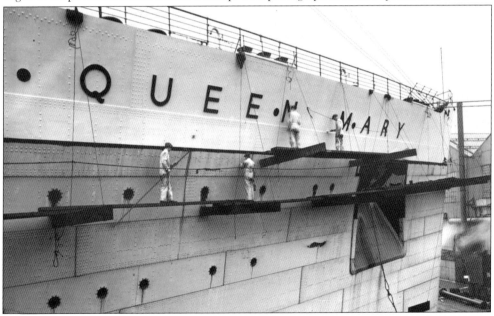

For a ship that required 13,000 gallons of paint during construction, painting her name in 2.50-foot-high gold letters was a surprisingly delicate task. Noncorrosive anti-fouling paint was used below the waterline to protect from marine growth, while a new rust-preventive paint called Anodite was used elsewhere. Throughout the interior, special fire-resistant paints were used. As with all ships, regular repainting kept many men busy throughout her service.

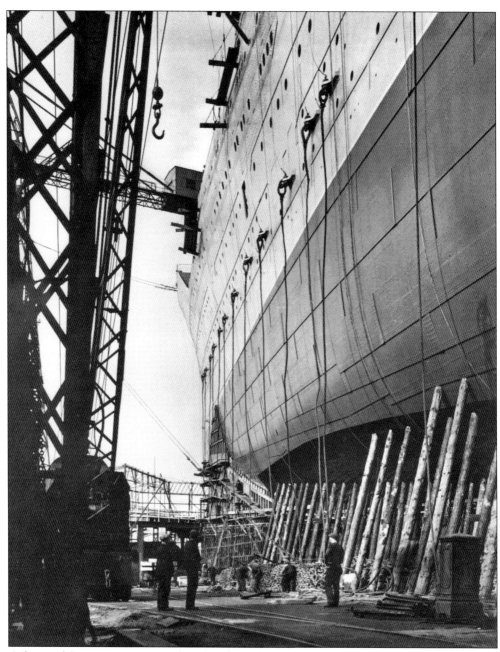

A forest of Oregon pine was used to distribute the ship's weight over the sliding surface of the launch. Heavy barriers were erected to protect the expected crowd from dislodged timbers and flying debris. A suite of rooms paneled in bird's-eye maple had been constructed for the comfort of the king and queen. As workers cleared the shoring, Hull 534 was left groaning and creaking. "Feeling her weight," the engineers said. "She's alive and ready to launch tonight." Colossal drag chains would be required to arrest the ship's speed and keep it from moving too far once it entered the water, while tons of grease, oil, and soap would at the same time keep it in motion. At the time of launch, the ship was painted white to allow movie cameramen to get a good shot, even on a gray English day.

The launch cradle held the massive ship upright as she slid into the waters of the Clyde River. Gigantic drag chains slowed her speed down the ways. It took platoons of men weeks to coerce the 2,400 tons of chain clamped to the *Queen Mary* into place, set to uncoil with clanks and screeches as it braked her descent.

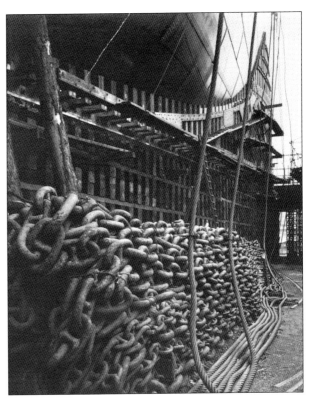

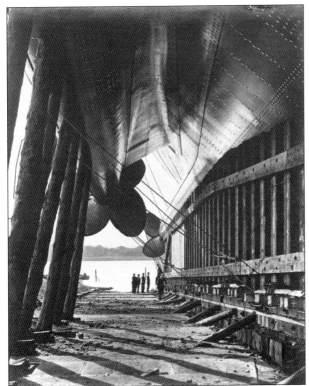

In Tudor times, royalty seldom attended launches. Women were never present. Wine was poured at the four compass points before the goblet was tossed overboard as an offering to the elements. Breaking a bottle of wine across the bow began in the early 19th century. Since an early christening when a royal lady threw the bottle and missed, injuring an unfortunate spectator, a ribbon has kept the bottle attached from above.

A commemorative booklet was produced in honor of the launch of Hull 534, but the number of these souvenirs printed was insufficient to be distributed to the crowds that assembled to watch. Those with enough income paid the not insignificant sum of 15 shillings for a seat in the stands, while tens of thousands more lined the banks of the Clyde.

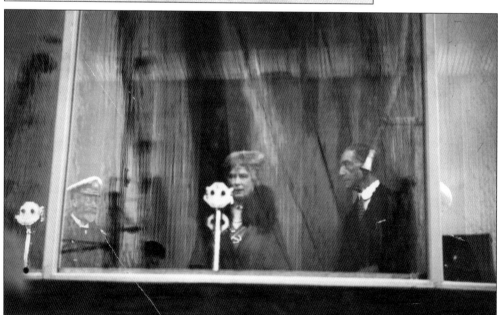

On September 26, 1934, a quarter-million Britons turned out in the pouring rain for the christening and launch of Hull 534. The queen, escorted by King George V, stepped to the microphone and proclaimed, "I am pleased to name this ship *Queen Mary*." And with the smash of a bottle of Australian wine on the bow, Britain's first superliner went down the slipway and into the water.

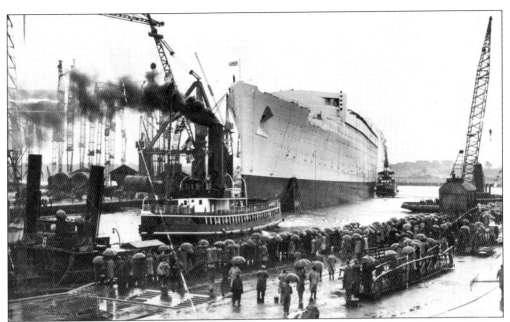

The launch had to be timed to begin 50 minutes prior to the tide's peak, thus allowing sufficient time for the ship to transfer to the fitting out basin while the water was deep enough. Given the broad area of the ship's side and its virtually hollow interior, winds exceeding 30 miles per hour would cancel the event. For all the preparation, the ship traveled the 1,200 feet in under two minutes.

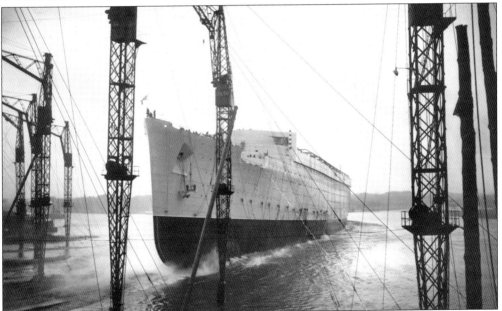

The launch of any ship is a critical moment, and the launch of the new Cunard White Star flagship was no different. Newspaper accounts describe grim-looking officials waiting anxiously for the *Queen Mary* to prove her seaworthiness—which she did, with flying colors. Within a half-hour of the ceremony, the *Queen Mary* was surrounded by tugs and towed to a neighboring berth, where the fitting out of the 72,000-ton ship began immediately.

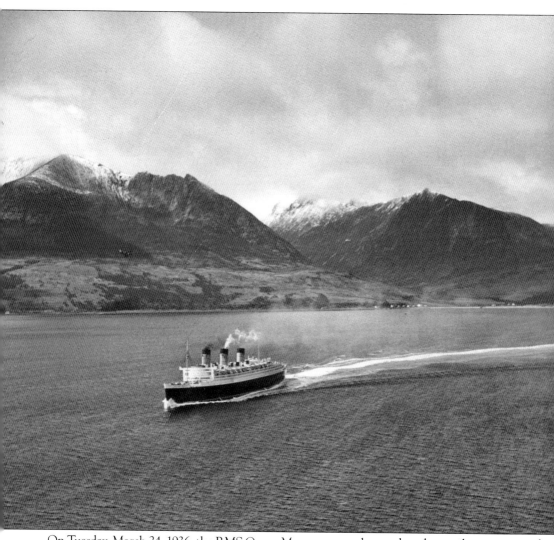

On Tuesday, March 24, 1936, the RMS *Queen Mary* was complete and ready to sail, as announced by four deafening whistle blasts. More than 1 million people gathered to watch her 15-mile journey down the Clyde (which had been widened at several points to accommodate her size) to her home port of Southampton. Despite the precautions taken to lessen her draft—she was unfurnished, all but two lifeboats had been removed, and she carried only enough fuel to get her to her new home—she was caught by a gust of wind and her stern ran aground. It was several anxious moments before the tugs could pull her free to continue—undamaged—her stately progress through the Firth of Clyde to the open sea and then to Southampton, from which she would sail on her maiden voyage. The sea trials were crucial, as they would determine whether her numerous design innovations were successful.

Two

BEHIND THE SCENES

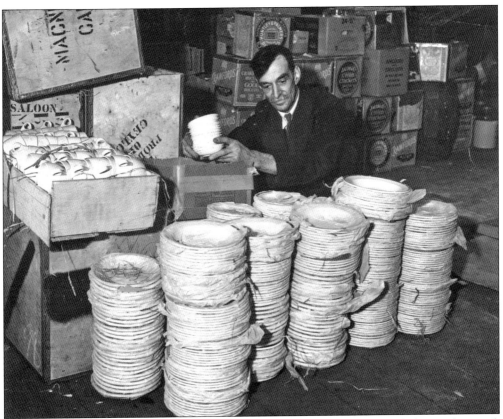

It took an enormous variety of china, silver, and glassware to make passengers feel properly served. It would have been considered quite the faux pas to serve salad on a plate designed for fish, or consommé in a cream soup bowl; and the kosher kitchen had its own demands. John Maddock and Sons, Ltd., produced more than 30,000 pieces of crockery for the maiden voyage alone. An equal number of pieces in matching china were manufactured by Jackson and Gosling, Ltd. The pattern for both featured a simple, but elegant banding of gray, black, and golden salmon. Tea sets were a distinctive cube shape that made them easier to store. About 22,000 crystal glasses in various sizes and shapes were circled with a design that evoked the waves of the North Atlantic. There was also silverware to be considered, as well as special casseroles, ramekins, scallop shells, serving trays, and much more, and it all needed to be in place before the ship left port.

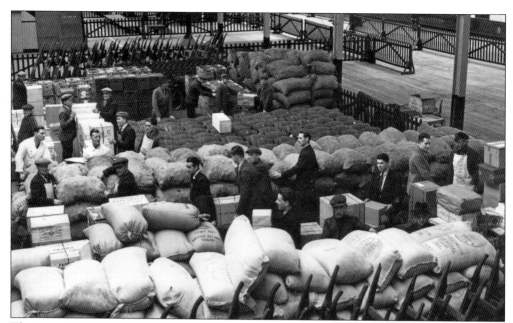

The amount of provisions required for a single voyage was monumental: 70 tons of meat, 3 tons of butter, 2,000 pounds of cheese, 70,000 eggs, 4,000 pounds of tea and coffee, and 10,000 pounds of sugar, plus some 10,000 bottles of wine and 40,000 bottles of beer. Complete stores had to be purchased and loaded within a few days in port, since there was no opportunity for restocking at sea.

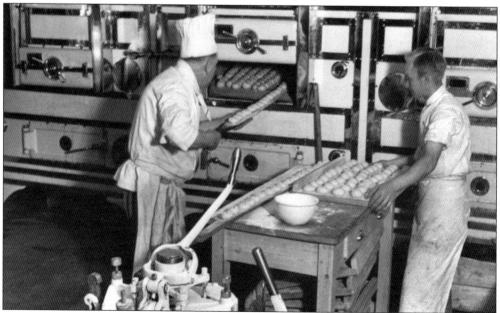

Both kitchen and bakery staffs were kept busy with the demands of feeding passengers and crew. An army of people baked dinner rolls, stirred pots on stoves, washed dishes, peeled vegetables, removed meat from refrigerated rooms, and made sundaes from a huge freezer devoted to nothing but ice cream. Smuggled nylon stockings found near the main kitchen by customs inspectors in 1949 were probably not on the menu.

An elaborate bakery existed onboard, with both electric and steam ovens, and a dough-mixing machine with a 280-pound capacity. Shown here is a multitiered cake, a testimony to the baker's skill and sea legs; these elaborate concoctions could even be prepared in rough seas. Today wedding cakes are not uncommon aboard the ship, as the onboard wedding chapel is a popular venue for brides and grooms.

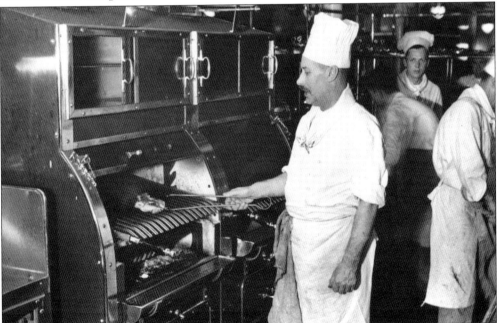

On a ship the size of a small city, a separate kitchen and pantry were required for the Verandah Grill. Food had to be served quickly, efficiently, and hot in an à la carte restaurant that had the upper tiers of society vying for tables. Rumor had it that that some travelers would change the date of their sailing if the Verandah Grill could not ensure them a seat.

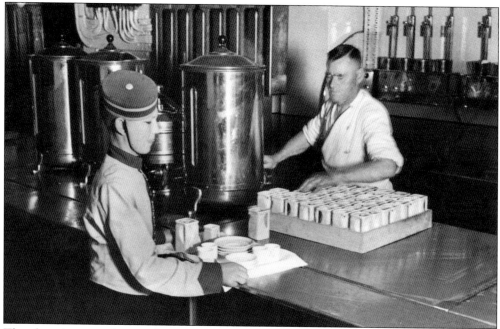

The gleaming, stainless steel–appointed kitchens aboard the *Queen Mary* were divided by class—with the cabin class kitchen forward and the tourist class kitchen behind it—although the kitchens shared so many service areas, including the bakery and pastry preparation, vegetable preparation and the dishwasher, that it was, for all intents and purposes, class free.

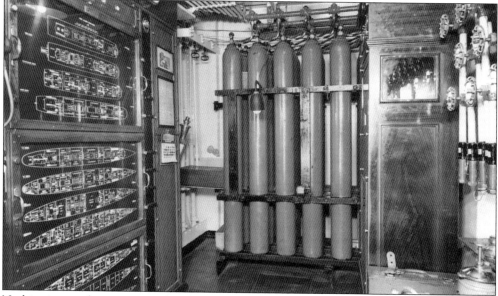

Nothing is more dangerous on a ship than fire, and Cunard White Star, like all shipping companies, instituted strict detection and prevention practices aboard the *Queen Mary*. In addition to built-in and automatic systems, crew details patrolled the ship looking for fire hazards. Fire suppression systems and state-of-the-art fire detection systems were installed to ensure passenger safety. New ideas, particularly adequate passageway escapes, were adopted from building fire prevention and protection practices.

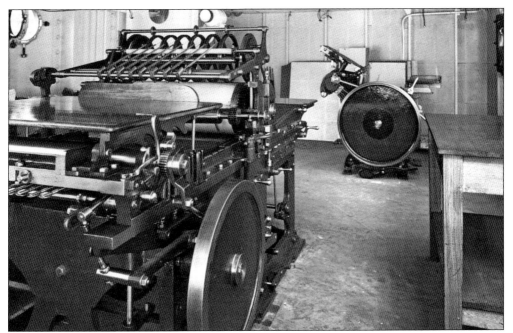

After news was decoded in the wireless room, printers worked through the night so that passengers would find the Cunard newspaper, *Ocean Times*, outside their door every morning. Located at water level on the starboard side, and under the first funnel far from the engine room so the ship's vibrations did not interfere with the presses, the print shop concentrated on producing the daily notices and menus during the daytime.

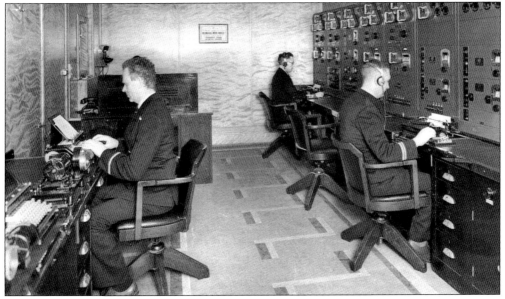

Because the radio equipment on the *Queen Mary* was the most powerful ever installed on a ship to date, regular radio programs from the United States and Europe could be picked up. Onboard, 38 loudspeakers were divided into eight individually controlled networks, providing passengers with unprecedented choices in terms of the airwaves. Passengers could choose between radio broadcasts, dance music, and other shows as they were picked up.

No one wanted to admit that people could get sick on an ocean cruise, but illness is part of the human condition. Although ship officials refused to comment, fellow passengers reported that poet T. S. Eliot spent several days of his voyage in the hospital after a mild heart attack aboard ship in 1956. In first class, the genders were separated. This is the women's hospital.

In addition to separate hospital rooms for the various classes, the *Queen Mary* also had an operating theater and pharmacy aboard. The ship employed a staff of doctors and nurses to care for passengers and crew. Occasionally, if there was an illness or disaster along the ship's route, the *Queen Mary's* doctors would send instructions by radio or the patient would be taken aboard for treatment.

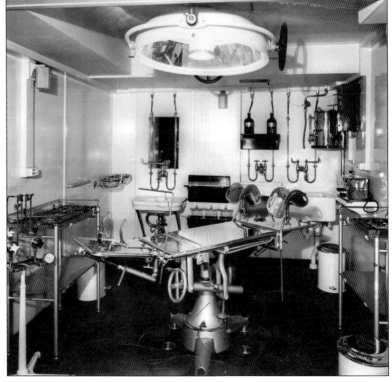

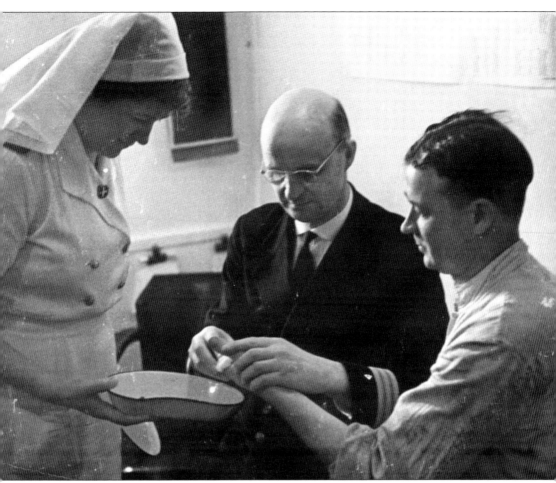

Some trips kept the medical staff busy. A North Atlantic gale in December 1936 left many passengers and crew members nursing injuries. Most problems were minor, but a stewardess sustained a serious cut on her nose. Two of the crew died of heart attacks on the same voyage. A tourist class barkeeper was brought back to England for burial, but the cabin steward was buried at sea. Still, passengers, both famous and unknown, tried to make the best out of bad weather. In spite of a gale so severe that her bed crashed against the wall until stewards clamped it down, French opera star Lily Pons kept her promise to sing for passengers. Ropes were placed for audience and artists to grasp. "I let go of the rope," she said, "and the next thing I knew I was sliding across stage, but I kept on singing." Upon reaching Paris, she wore a muff during her concert to hide the bandages covering a finger injured on that rough crossing.

Like everything else aboard the *Queen Mary*, the crow's nest was state of the art. Rising 130 feet above the ocean, it was accessed by 110 steps inside the mast and boasted a roof and weather screen, and a direct telephone link to the bridge. In a nod to the comfort of the crewmen who would stand lookout, a small electric heater staved off the North Atlantic chill.

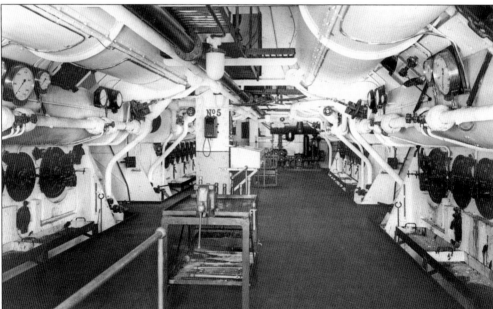

There were five boiler rooms housing 27 double-flow boilers. One room was allocated for each of the four turbines, with a fifth acting as an auxiliary. Each boiler operated at a pressure of 400 pounds per square inch and maintained an average temperature of 700 degrees Fahrenheit. During operation, each boiler required 150,000 gallons of purified, softened water to keep mineral solids from clogging the boiler tubes.

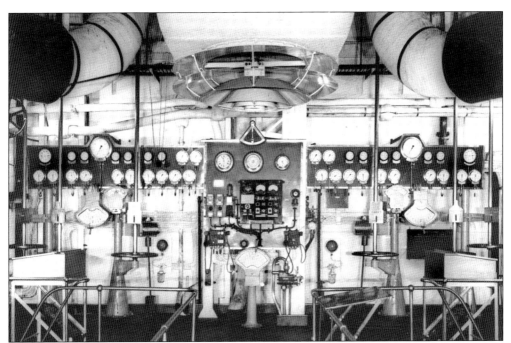

The *Queen Mary*'s seven 1,300-kilowatt generators were allocated for specific functions, with four used to power the ship's propulsion and three designated for hotel services. Each group required extensive switchboards, located both fore and aft, and displayed a mind-boggling array of switches, dials, levers, and relays. A 37-foot-long panel was required to service the ship's hotel functions, while another 46 feet was allotted to propulsion controls.

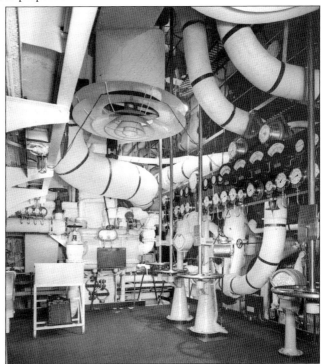

Every possible precaution was taken to ensure that the electrical supply aboard the *Queen Mary* was constant and safe, avoiding the overheating endemic in earlier generations of ships. Special state-of-the-art instantaneous-overload relays were fitted to each generator to manage flow in case of another generator's failure. Feeder circuits on the generators redirected any spike in power so that it could be reapportioned between the other generators, thus preventing an overload.

Most of the crew found little time to relax when at sea, but when that time did come, there was a traditional English pub onboard for their use called the Pig and Whistle. Such an amenity was an enormous departure from earlier steamers, where crews were often segregated by the type of work they performed and any imbibing of alcohol meant the loss of one's job.

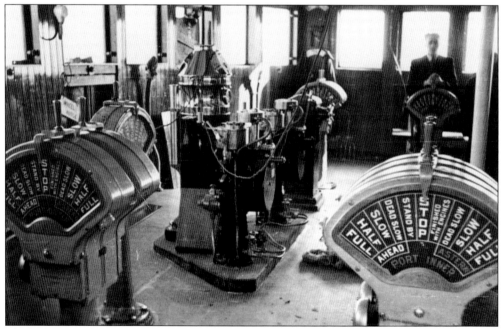

The bridge and wheelhouse contained all the latest, most up-to-date navigating equipment for 1936, with gleaming dials, precision machinery, and shiny brass. The points on the magnetic compass, however, were stitched in bright silk by expert needlewomen in Glasgow, an unexpectedly homey touch in an area of the ship where technology ruled.

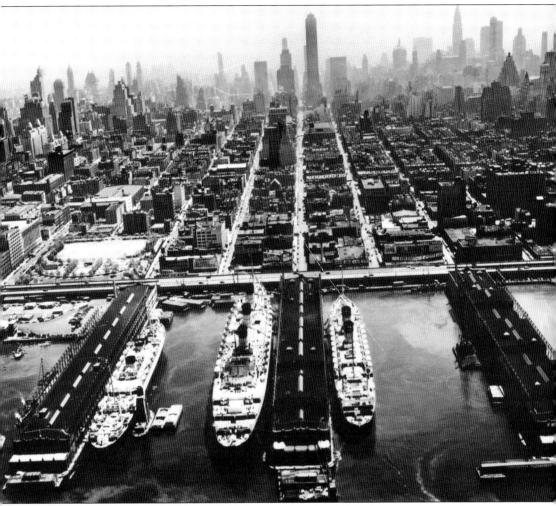

The patron saint of travelers had to work overtime in October 1938 when a tugboat strike made landing the huge liner, loaded with 1,601 passengers and $23 million in gold, unusually perilous. Commodore Robert B. Irving told the newspapers, "I looked at my St. Christopher's medal and asked if I could make it, and he told me to go for it, and I did." His act of courage paid off, and the *Queen Mary* took only 34 minutes to nestle alongside the Cunard White Star pier, the same length of time required with her usual dozen escorts. An hour later, Irving reported, "She came in all right, but I haven't stopped shaking yet."

Although the crew was expected to present a polite façade to all passengers, in private life they would be less than human if they did not take advantage of the social mileage engendered by rubbing shoulders with the rich and famous. In this picture, crew members in the radio room admire a scrapbook of famous passengers.

Merchant ships often fly a house flag that identifies the ship's company owner. After the Cunard White Star Line merger in 1934, both house flags were flown from all the combined line's ships, with the original owner's flag on top. In the case of the *Queen Mary*, the Cunard flag, a gold-crowned lion holding a globe on a red background, was flown above the White Star flag.

Bellboys were among the busiest crew members. They ran messages and delivered the daily *Ocean Times* newspaper, radiograms, and anything else that needed to be carried from one place to another. Every morning at muster the boys' uniforms were inspected (along with their fingernails), and they were given the day's assignments. Their routine included exercises in the gym at 7:00 a.m. and swimming in the first class pool after 7:00 p.m.

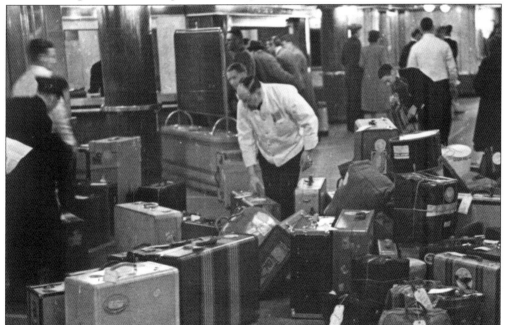

Most second and third class passengers arrived with one or two large trunks, but first class passengers traveled with mountains of luggage for the week-long crossing. Extensive wardrobes were required to dress appropriately for the ship's many activities. One society couple regularly traveled with 80 suitcases in their suite and another 75 in the hold, with special labels attached on each piece for each location.

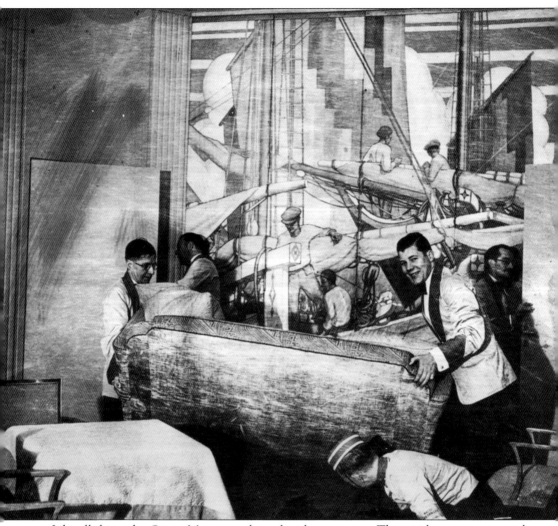

Like all ships, the *Queen Mary* was plagued with stowaways. The maiden voyage saw at least three, including an English sparrow that chose the wrong place to rest. The second, a workman with just £5 in his pocket, ended up happily employed scrubbing floors and washing dishes. The third, an enterprising young Canadian named Rahoma Siegal, was put off the ship at Cherbourg. She said she went aboard for a thrill. "I knew it would be a supreme experience, and it has been." The years around World War II saw an upswing in stowaways fleeing the war, and the ship was regularly searched for soldiers' wives and sweethearts. Sgt. Frank Hernsohn smuggled his dog home from France in a duffle bag. He said Dobbie "was a smart pup . . . never made a sound," and quickly became a favorite with the 8,000 men aboard. Even the *Queen Mary*'s final voyage featured a stowaway discovered walking the Promenade Deck. The 22-year-old woman said she became homesick during her vacation in Acapulco and hoped to reach Long Beach undetected so she could hitch a ride home to Brooklyn for Christmas.

Three

PUBLIC SPACES

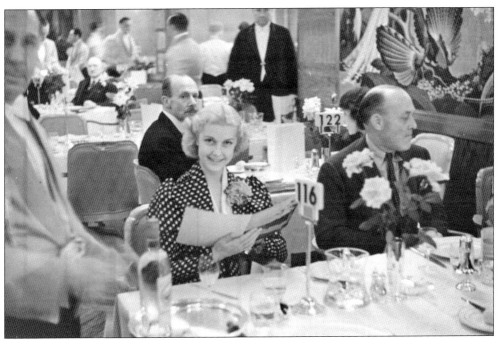

Among the more notable passengers on the *Queen Mary's* maiden voyage was 21-year-old film star Anita Louise. An actress from a young age, she had already appeared in such classics as *Madame Du Barry*, *A Midsummer Night's Dream*, *The Story of Louis Pasteur*, and *Anthony Adverse*. Newspapers reported that she was a regular diner in the Verandah Grill, yet here she poses in the ship's main dining saloon ordering her meal. After the ship's arrival in New York, newspapers reported she was the *Queen Mary's* "ace window shopper." For many years, Louise was a noted society hostess in Hollywood, and she eventually moved to television, where she had a regular role on the series *My Friend Flicka*. Anita Louise (1915–1970) lived long enough to see the *Queen Mary* brought to Southern California.

The first thing passengers did upon boarding, before even looking at their cabins, was to rush to the dining saloon, where the chief steward was assigning tables for meals. Passengers vied to sit with an officer, sit near the kitchens, sit away from the kitchens, sit with their friends, sit alone, sit near the entrance, sit near a porthole, or sit off in the corner. Rarely was everyone satisfied.

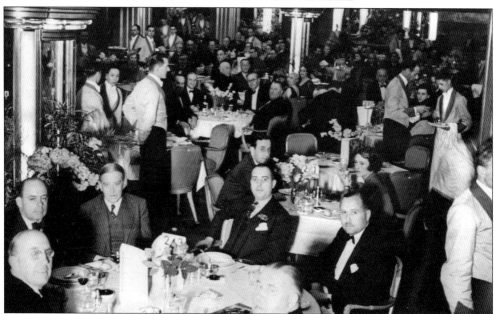

Dining at sea was always a momentous occasion. In addition to fine foods, there was the fun of watching other passengers. On June 26, 1936, when this photograph was taken, guests could have spotted the second cousins of the king of England, financier Bernard Baruch, or actress Bea Lillie. Aspiring actors would have been able to discern theater owner Lee Shubert or studio head Carl Laemmle in the crowd.

When it was built, the first class dining room was widely publicized as the largest room afloat, able to serve 800 passengers at a sitting. Eight massive pillars, augmented with several smaller ones, held up the spacious ceiling, framing the room's focal point, MacDonald Gill's monumental inlaid-wood map had illuminated crystal ships that moved during the voyage and allowed diners to follow the *Queen Mary*'s progress across the North Atlantic.

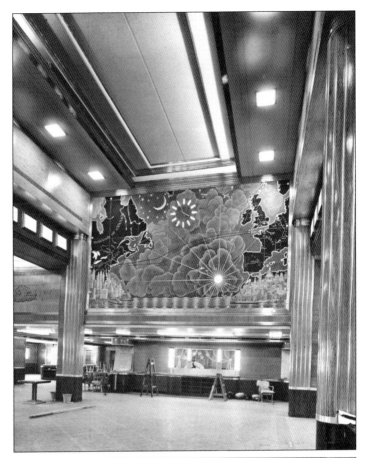

The spaciousness of the first class dining room was particularly obvious prior to the installation of more than 800 chairs made of sycamore and upholstered in red. The walls were paneled in three shades of Brazilian peroba, with silver-bronze metal accents. The floor was a material dubbed "Korkoid," and like the rest of the room it was colored in autumnal tones. The mural by Phillip Connard is called *Merrie England*.

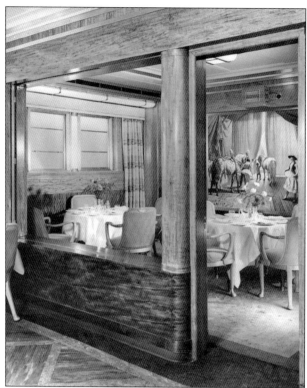

Private dining rooms were available for those fed up with the riffraff of first class or, more likely, those who wished to host a quiet party of friends. If the rooms were not occupied, doors could be opened to connect the forward private dining rooms to the main dining area. A circus painting by Dame Laura Knight adorned the forward portside room.

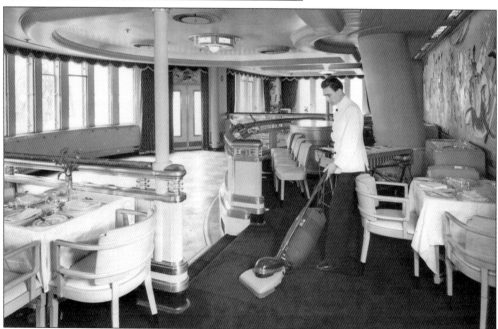

The Verandah Grill was the popular alternative dining spot for the *Queen Mary*'s transatlantic crossings—reservations required! Breathless accounts of the maiden voyage recount that for the additional cost of five shillings per meal ($1.25), passengers could enjoy their meals at a private table with a superb view of the sea in this light and airy room located directly above the propeller.

The striking graphics that made menu covers inviting were usually printed before sailing, with the same image used on all Cunard vessels. This example, by artist Rebel Stanton, shows the most decorative of the 596 clocks aboard the *Queen Mary*. The original bas-relief in sprayed nickel (whereabouts unknown) was located in the second class lounge.

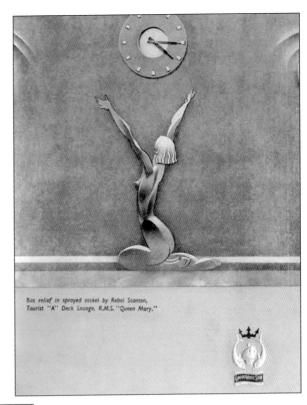

Bas relief in sprayed nickel by Rebel Stanton, Tourist "A" Deck Lounge, R.M.S. "Queen Mary."

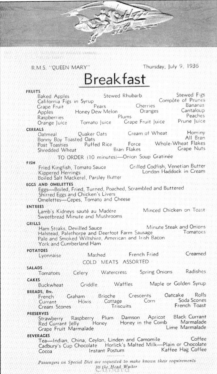

R.M.S. "QUEEN MARY" Thursday, July 9, 1936

Breakfast

FRUITS
Baked Apples Stewed Rhubarb Stewed Figs
California Figs in Syrup Compôte of Prunes
Grape Fruit Pears Cherries Bananas
Apples Honey Dew Melon Oranges Cantaloup
Raspberries Plums Peaches
Orange Juice Tomato Juice Grape Fruit Juice Prune Juice

CEREALS
Oatmeal Quaker Oats Cream of Wheat Hominy
Bonny Boy Toasted Oats All Bran
Post Toasties Puffed Rice Force Whole-Wheat Flakes
Shredded Wheat Bran Flakes Grape Nuts
TO ORDER (10 minutes)—Onion Soup Gratinée

FISH
Fried Kingfish, Tomato Sauce Grilled Codfish, Venetian Butter
Kippered Herrings London Haddock in Cream
Boiled Salt Mackerel, Parsley Butter

EGGS AND OMELETTES
Eggs—Boiled, Fried, Turned, Poached, Scrambled and Buttered
Shirred Eggs and Chicken's Livers
Omelettes—Cepes, Tomato and Cheese

ENTREES
Lamb's Kidneys sauté au Madére Minced Chicken on Toast
Sweetbread Minute and Mushrooms

GRILLS
Ham Steaks, Devilled Sauce Minute Steak and Onions
Halstead, Palethorpe and Deerfoot Farm Sausage Tomatoes
Pale and Smoked Wiltshire, American and Irish Bacon
York and Cumberland Ham

POTATOES
Lyonnaise Mashed French Fried Creamed
COLD MEATS ASSORTED

SALADS
Tomatoes Celery Watercress Spring Onions Radishes

CAKES
Buckwheat Griddle Waffles Maple or Golden Syrup

BREADS, Etc.
French Graham Brioche Crescents Oatcake Rolls
Currant Hovis Cottage Corn Soda Scones
Cream Scones Triscuits French Toast

PRESERVES
Strawberry Raspberry Plum Damson Apricot Black Currant
Red Currant Jelly Honey Honey in the Comb Marmalade
Grape Fruit Marmalade Lime Marmalade

BEVERAGES
Tea—Indian, China, Ceylon, Linden and Camomile. Coffee
Cadbury's Cup Chocolate Horlick's Malted Milk—Plain or Chocolate
Cocoa Instant Postum Kaffee Hag Coffee

Passengers on Special Diet are requested to make known their requirements to the Head Waiter

White Star

Food aboard the ship was the equal of any fine European hotel, and the chefs prided themselves in being able to produce any dish a passenger requested. Menus were extensive, with choices ranging from caviar or consommé, to petits fours or meringue framboises, with grills, joints of meat, vegetables, and roasts in between.

39

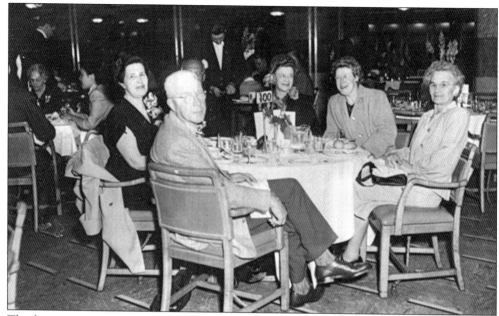

This happy group was photographed in 1955 in the second class dining room. Edwina Corrigan (second from right) is enjoying the voyage undeterred by the memory of having survived the sinking of the RMS *Titanic* in 1912. Years later, as a resident of Southern California, she would frequently visit the *Queen Mary* in Long Beach until her death in 1984 at the age of 100. (Courtesy of Don Lynch.)

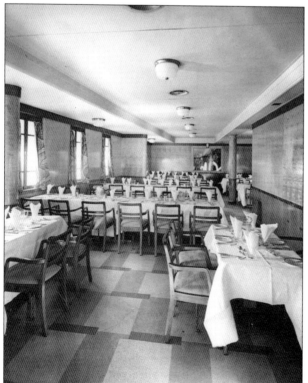

Gone were the days when third class passengers were called "steerage" and had to bring their own provisions. Onboard the *Queen Mary*, people traveling in this class were as likely to be vacationers on a budget as they were immigrants. The dining room was now more restaurant than mess hall, boasting real chairs that were only attached to the floor by ropes in rough weather, serving enticing selections amid a modern atmosphere.

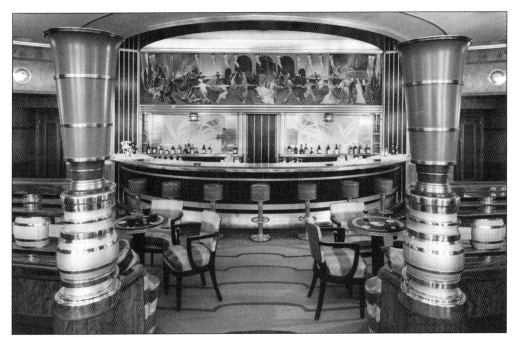

A discerning passenger could raise a cocktail glass to the artwork in the first class Observation Lounge. The mural over the crescent sweep of the bar is by A. R. Thomson. Sleek mermen ride fish on a balustrade by A. Crompton Roberts. Enameled pylons guard a raised platform with a generous semicircular view of the sea.

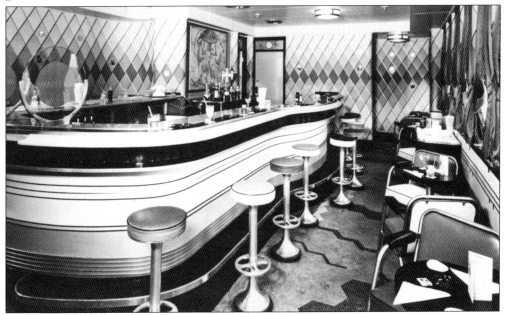

The refit of the *Queen Mary* following World War II provided Cunard with the ideal opportunity to upgrade the ship and improve amenities for passengers. The Mermaid Cocktail Bar and adjoining starboard Garden Lounge were based on similar rooms aboard the *Queen Mary*'s sister ship, the *Queen Elizabeth*. The new Mermaid was a favorite with cabin class passengers. The room offered excellent views and an upgraded selection of refreshments.

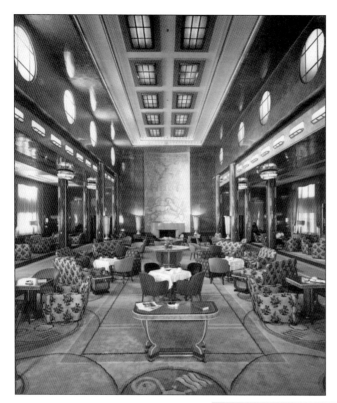

The Main Lounge was the social center of the first class sphere. Located near the center of the Promenade Deck, it had comfortable chairs for daytime conversations. By night, it became a cinema, a live theater, or a dance floor. Although it was a large room, the warm gold of the onyx lamps and the burnished wood of the walls gave it a cozy, comfortable ambience.

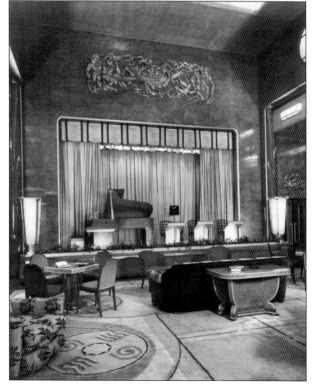

Rugs in the lounge could be pulled up to permit dancing, with enough space for a good-sized band or orchestra on the well-equipped stage. A bas-relief by Maurice Lambert hovers over the proscenium arch. Entitled *Symphony*, it features floating busts of musicians accompanied by singers. Smaller companion pieces are placed over the doors on either side of the stage.

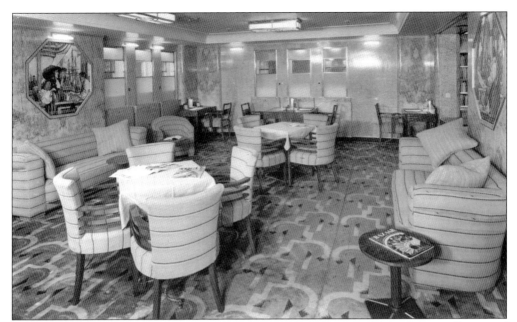

Should one have wished to find something to read on the voyage, the library kept a collection of books in glass-fronted cases. A passenger could casually pick up a sensational crime novel, browse through Shakespeare's plays, or study the theories of Einstein. Readers who preferred French, German, or Italian writings could find something to their taste, as well. This photograph shows the 1936 decor.

Prior to cell phones and e-mail, writing letters and postcards was an important part of any voyage. "Wish you were here" let friends at home know they were remembered. Passengers could, of course, write comfortably in their own rooms, but the first class writing room provided elegant desks of white ash with pear-tree letterboxes and banding.

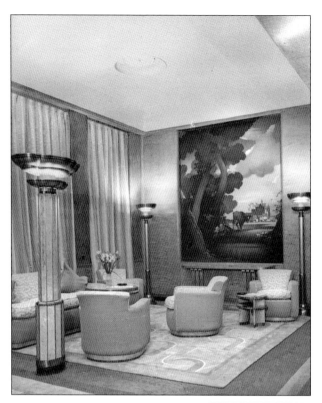

A serene cow presides over a corner of the first class Long Gallery. Flanked by lovely Art Deco–style light fixtures, the painting by Bertram Nicholls, called *A Sussex Landscape*, creates an inviting place for conversation. On the other end of the 118-foot-long room, a tranquil river gleamed in Algernon Newton's *Evening on the Avon*. The floor was covered with rugs in warm tones of fawn and brown.

The first class smoking room featured two of the most aggressively modern pieces on the *Queen Mary*: *The Sea* and *Dressed Overall at the Quay*, by Edward Wadsworth. According to lore, the decidedly surrealist *The Sea* was not a favorite with the gentlemen who retired there to enjoy a smoke. Instead, they preferred to face the aft fireplace (an actual coal-burning fireplace), which was a much more traditional vista.

The second class smoking room (now the wedding chapel) featured sinuous linen-fold paneling in curly oak. A focal point of the room was a dramatic painting by Charles Pears of the *Mauretania* arriving at Rosyth to be broken up for scrap. Passengers may not have cared, but it was a melancholy subject for some crew members who had probably worked aboard the *Mauretania* before transferring to the shiny, new *Queen Mary*.

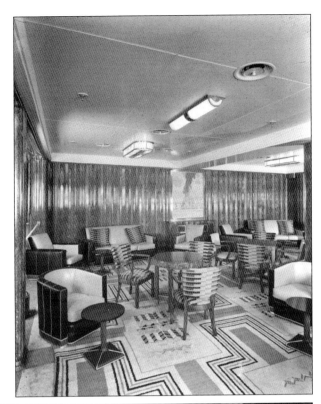

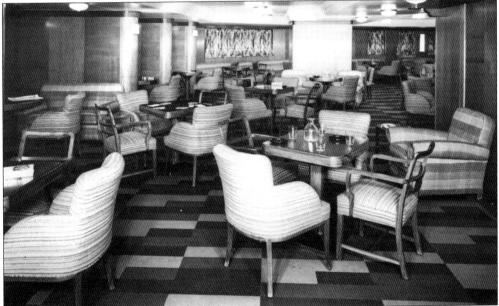

Third class, while comfortable, was not nearly as elegant as first or even second. Rather than exotic woods, walls on those decks were finished in oak veneer. Twenty-two windows provide a sweeping view of the forecastle and the ocean beyond. Being near the bow, the floor angles upward with the sheer of the decks; still, the furniture was comfortable, and at one end of the smoking room a bar was provided.

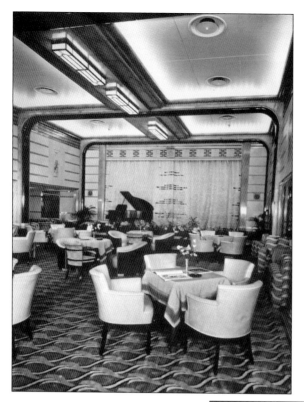

The second class Main Lounge had a 16-foot-high ceiling in the center over the dance floor. Normally the room could seat 210 passengers, but when set up as a cinema, the number was nearly doubled. The stage, which featured the only curtains in a second class public room, was outfitted with spotlights and footlights for theatrical productions.

The walls of the second class Main Lounge were covered in green, ivory, and silver-colored leather, with the lower portions paneled in thuya burr, birch, and maple. The furniture was covered in green, cream, and black fabric, and the floor in a heavy carpet over cork flooring. Twenty-eight windows overlooked the ocean. This pleasantly elegant room was the center of social life in second class.

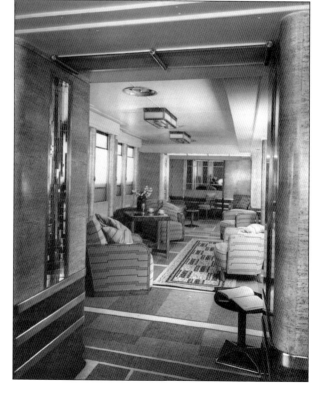

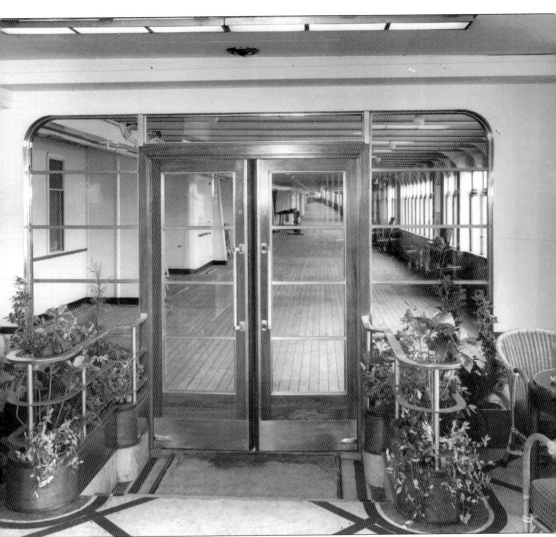

Watering the plants that gave the second class Garden Lounge its name would have been a small task for the ship's full-time florist. Gardening at sea presents problems not seen on land, so it was vital that he know which plants were hardy travelers. The job included tending hydrangeas and ferns, sponging salt off the palms, and keeping roses, carnations, and gladioli refrigerated so guests could order fresh flowers mid-ocean. Cunard White Star advertised the gardener's expertise in selecting an evening corsage—he certainly could not send a lady to dinner wearing wilted flowers. On the maiden voyage, he most likely cared for specially bred Queen Mary roses, as well. The U.S. Department of Agriculture issued a special permit to allow Lady Bates, the wife of Cunard's chairman, to present them to Eleanor Roosevelt.

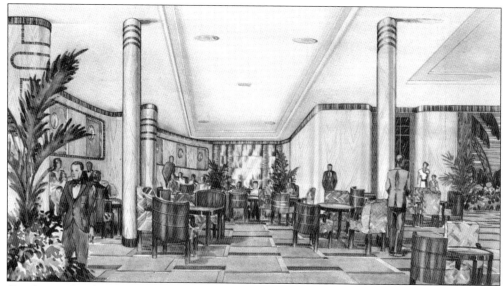

One hopes this drawing did not fool people into believing that the third class Garden Lounge came equipped with a two-story-high ceiling and elegantly dressed passengers. The actual room was much more compact, with a low ceiling, a combination of cane furniture as well as sofa chairs, and was so close to the bow that the floor sloped uphill, following the sheer of the deck.

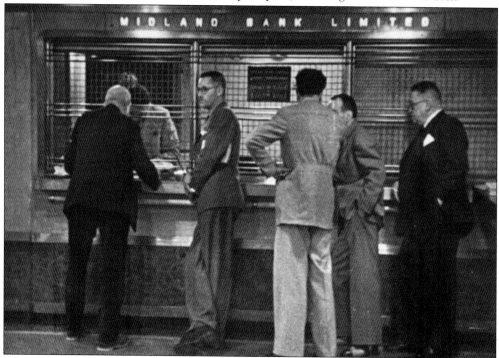

Midland Bank began opening branches aboard Cunard liners in 1920, so passengers could cash traveler's checks or change money before reaching their destination. Any balance on an account opened at sea could be transferred to a land-based branch or held for the return trip. Some passengers would open an account mid-ocean just to get checks inscribed "Branch Aboard R.M.S. *Queen Mary*" to spend aboard or keep as a souvenir.

48

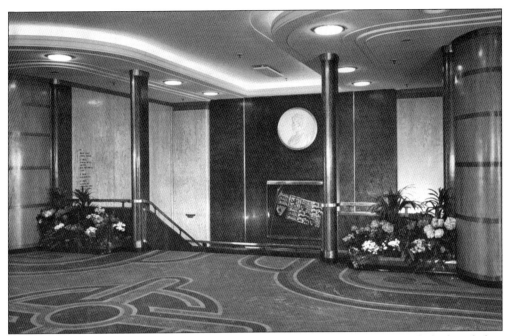

The grand sweep of the main staircase set the scene for first class passengers. Flashed opal glass with a design of darting birds charmed passengers at every landing. Much of the glass on the ship, especially in first class, had a subtle peach or pink tint, making it flattering to a complexion that may have been feeling a bit green from North Atlantic waves.

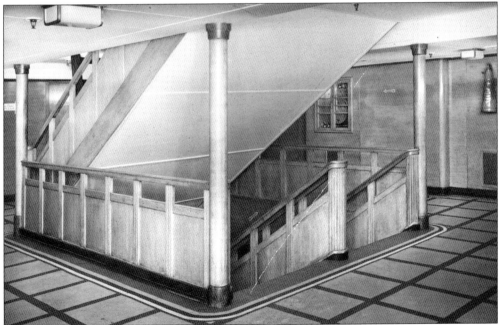

Third class had a serviceable wood staircase without the elegant lines of the main staircase or the decorative, aviation-themed wire glass that adorned second class. It was just a good, solid, wood staircase, useful for getting from deck to deck. At some point, bumps were added on the railing, reputedly because too many children found it to be a perfect shipboard slide.

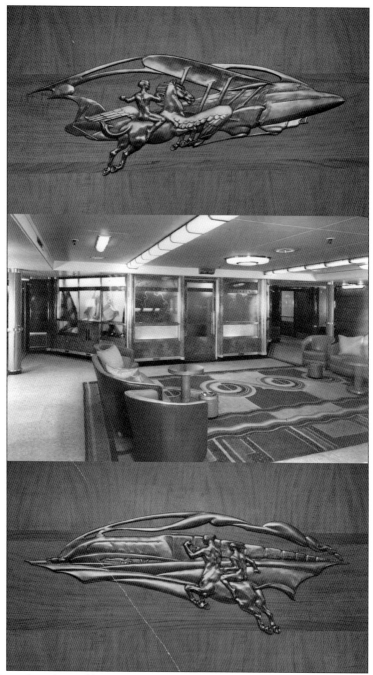

Although the onboard travel bureau could help passengers find hotels and train schedules, some of the more unusual forms of travel in Maurice Lambert's decorative panels were probably not available for reservations. The portside panel shows a centaur racing a silvery Art Deco–style nude to a streamlined train, while the starboard side has Pegasus flying up to an airplane with an equally elegant and naked Bellerophon on his back. Although it primarily catered to visitors to the British Isles, a reciprocal agreement with the *Normandie* allowed the travel bureau to offer tickets for French railways as well.

Four

SUITES, STATEROOMS, AND CABINS

Advice from a group of experts in housekeeping led to changes in staterooms. Thanks to the women's help, specially molded hangers in the closets kept the filmy fabric of evening gowns safe from snags. Ample shoe compartments were another suggestion sure to be popular. A lady dressing for dinner had a lighted, full-length mirror to check that her dress hung correctly, a plug for her curling iron, and a specially lit dressing table for primping. In the first class dining room, the women decided that a delicate rose-pink upholstery would set off most gowns nicely. Their recommendations also included changes to the kitchens and curved corners in rooms for ease of vacuuming.

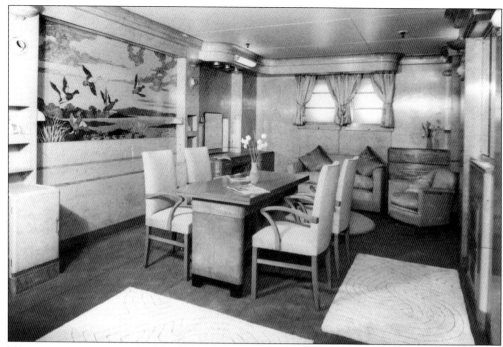

No two rooms were exactly alike, but all of the first class cabins featured a signature use of wood. Suites not only offered more space, but usually more elaborate artwork as well. The flying ducks are part of a complex marquetry panel meant to be enjoyed only by the inhabitants of this room.

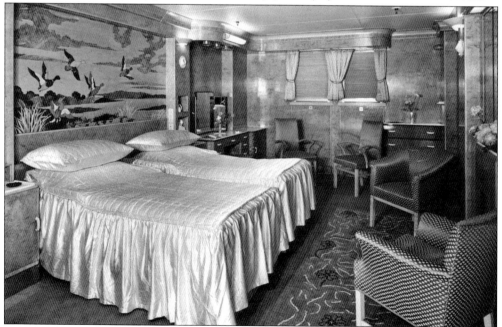

Rooms and suites were redecorated whenever necessary to keep up with changing styles, please a special passenger, or merely to ensure that the furnishings never looked worn. The marquetry panel shows that this room was, at various times, a bedroom or a room for conversation or private dining.

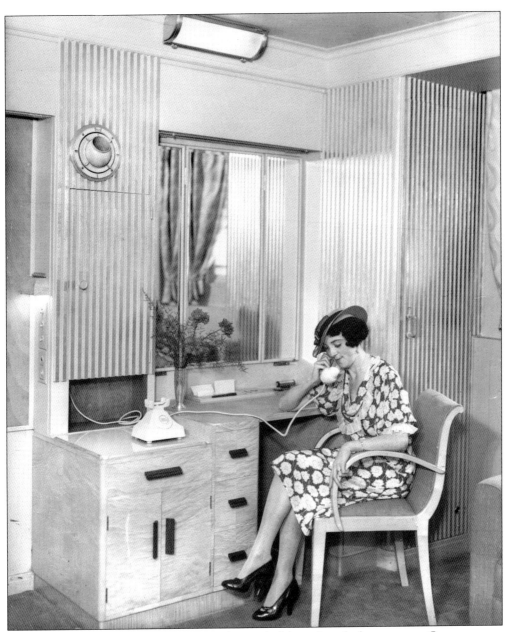

The ship's 14 telephone operators were justly proud of the radio-telephone system. One passenger could be talking to her father in Australia while another chatted with his broker on Wall Street, with all voices scrambled to foil eavesdroppers. "Scrambling words," an operator told Orrin E. Dunlap Jr., "is much easier than scrambling an egg; all they do is gently press a tiny toggle switch on the instrument panel," to convert words into an ethereal jargon that machines on shore can translate down to the smallest inflection. The ship had eight separate channels, four in and four out, each capable of operating independently of the others.

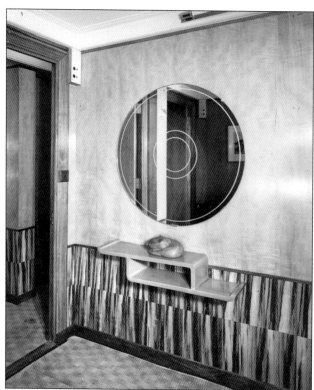

It was the details, as well as extra space, that set suites apart from cabins. A circular mirror and a shelf surmounting zebrawood paneling dominate this entry. All four pictures on these pages show various aspects of what are now the Queen Mary and King George suites, a set of rooms that can be occupied as two suites or combined into one larger space.

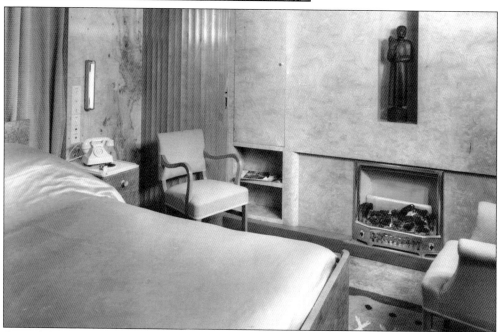

Curved, fluted wood hides closets in the suite's bedroom. Although the fireplace is now vestigial, it would have contained an electric fire to keep passengers cozy on a cold North Atlantic evening. The suite also boasts a maid's room, a sitting room, and an entry hall. A sliding door separating the two suites could be opened for larger parties or entertaining.

The dressing table in the suite shows some of the variety of woods used throughout the ship. Rounded corners on the built-in furniture not only lent an elegant, modern touch but were also safer during rough weather, with no sharp corners to bruise an unwary arm or leg. The suites are in the middle of the ship, a location that would minimize, but not eliminate, turbulence.

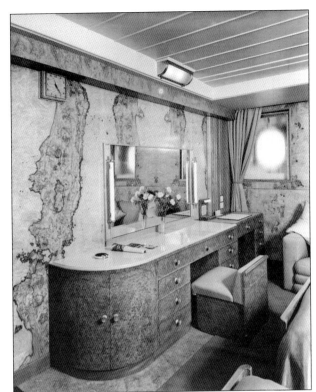

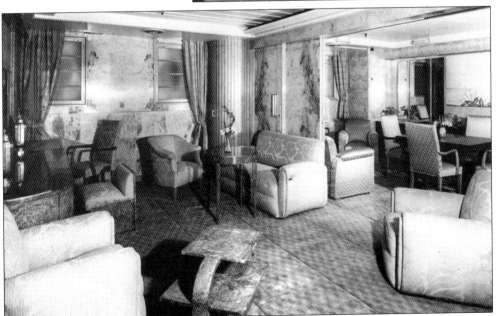

With the ship crammed full of people fleeing Hitler in 1939, J. P. Morgan chose to give up his sumptuous suite to refugees. When interviewed by the few newspapermen his smaller room would allow, one intrepid reporter was more interested in whether the length of the bed would support Morgan's tall frame than the rumors that he would be the British government's purchasing agent in the United States.

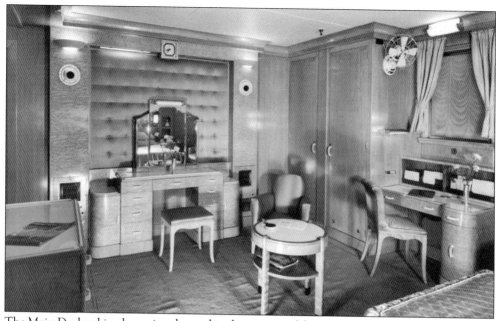

The Main Deck cabin class suites, located in the vicinity of the second funnel, were quite luxurious and, by shipboard standards, spacious, consisting of a bedroom, a sitting room, and a private bathroom. Each room was paneled in wood, frequently mahogany, with ivory satin curtains, bedspreads, and wall-to-wall carpeting overlaid with custom rugs. Furnishings and appointments differed from suite to suite, giving each room a distinct personality.

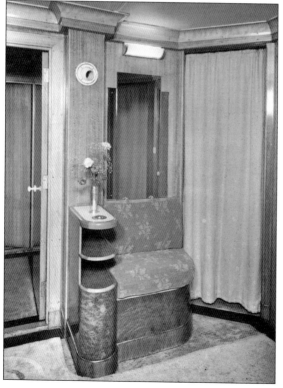

The entryway to one of the Main Deck suites illustrates the ship's unique interpretation of the Art Deco aesthetic. The heavy use of woods on furnishings of elegant simplicity made good Cunard's boast that there was a room for each passenger's tastes. Built-ins, with drawers and shelves, allowed passengers to live more comfortably on their crossing and reduced the potential projectiles that might hurtle across the room in bad weather.

Aboard the *Queen Mary*, special attention was paid to lighting, particularly in the interior spaces. Because of technical necessities, ceilings tended to be low and passageways narrow enough for passengers to reach a rail on either side in case of rough seas. In another one of the ship's design breakthroughs, extensive use of glass and mirrors, like this beautiful stepped design here, helped to open up rooms and lighten interiors.

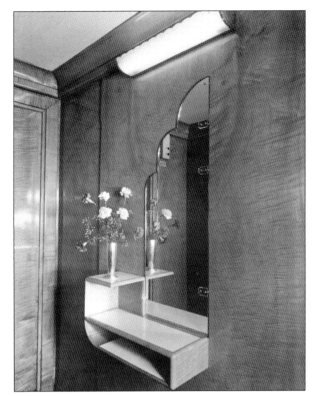

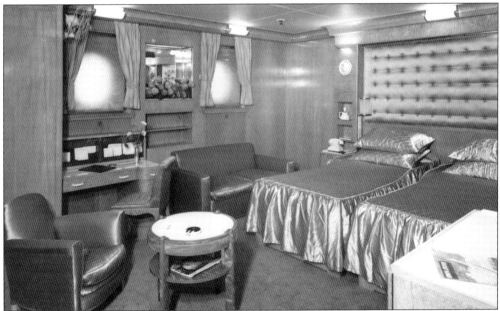

Many of the first class cabins had frosted glass that could be pulled over the portholes like a screen to diffuse the light. For comfort, rooms came equipped with fans and heaters that could be adjusted to suit the individual passenger. Even the *Queen Mary*, however, could not help if a husband wanted to let in fresh air through the porthole while his wife froze in front of the electric fire.

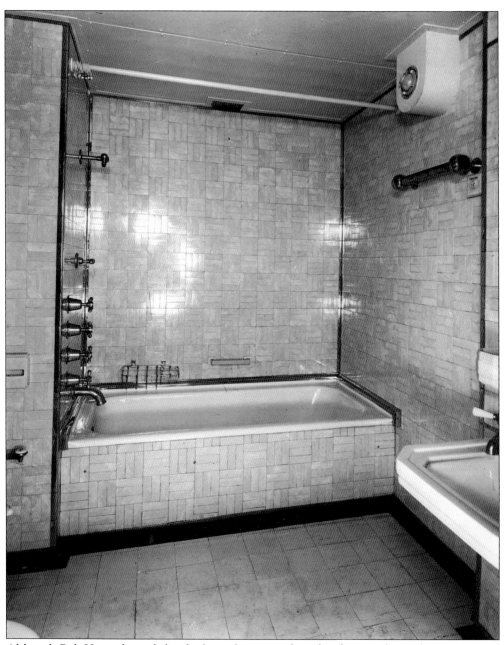

Although Bob Hope claimed that he knew he was in first class because his sink was equipped with faucets marked "Hot—Cold—and There'll Always Be an England," bathtubs in first class offered hot and cold salt water as well as fresh. Before desalination facilities were available, the ship carried a limited amount of fresh water, but filtering processes rendered salt water clean enough for bathing. Formica was used for wall coverings because it was, to quote the manufacturer, "beautiful and durable, light, fire-resisting, and proof against the action of heat and steam." No doubt those qualities were assets, but perhaps equally important was that in the 1930s, Formica was a fresh, modern material that lent an air of exclusivity.

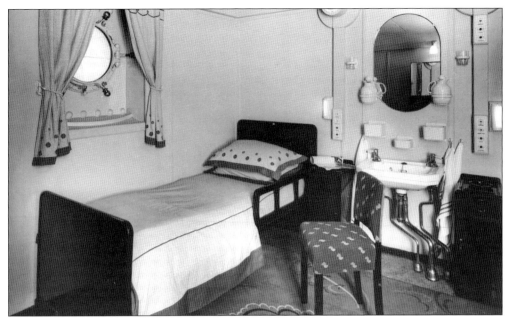

Second class (then called tourist class) staterooms, located on five decks (A to E), had less luxurious appointments and less room than the cabin class staterooms, but they were still far superior to the equivalent class arrangements on other ships. The rooms were designed to hold from two to four people, and approximately 80 percent of them had private bathrooms. They were decorated in shades of green, blue, and gold.

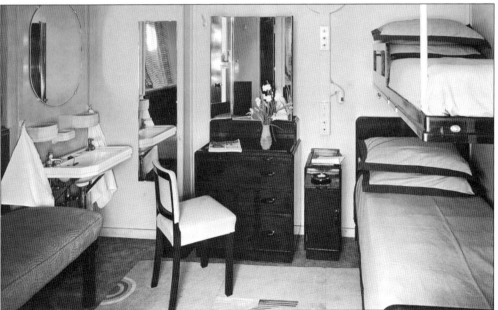

A woman who visited Scotland with her parents reminisced about being a 20-year-old traveling second class. Bon voyage gifts of fruit and flowers quickly became overwhelmingly fragrant in their windowless cabin. She also recalled mysterious holes appearing in her new rayon knit dress, a phenomenon she attributed to embers blowing from the smokestacks—although she said she did not especially like the dress, anyway.

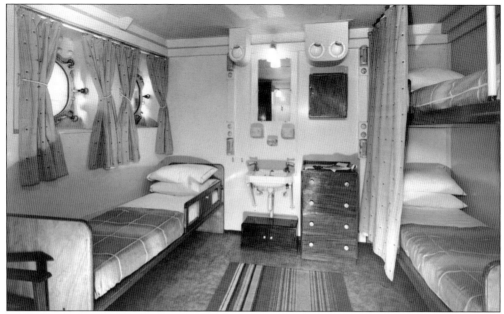

"Good news to thousands of students, teachers, and other thrifty people who travel third class," Cunard announced in 1936, "is the fact that the *Queen Mary* will actually offer rooms for two or four which will compare favorably with first class accommodations of only a few years ago," promising among other things, "ceilings and walls that . . . are completely covered, concealing the steel construction of the ship."

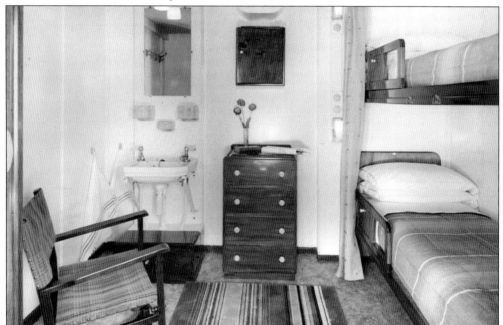

In designing the ship, Cunard made a deliberate decision to increase the percentage of third class cabins aboard, hoping to increase its share of the marketplace on its regular runs. Although advertisements touted the spaciousness and comfort aboard, the *Queen Mary*'s third class accommodations still relied on the traditional bunk beds and outside bathrooms.

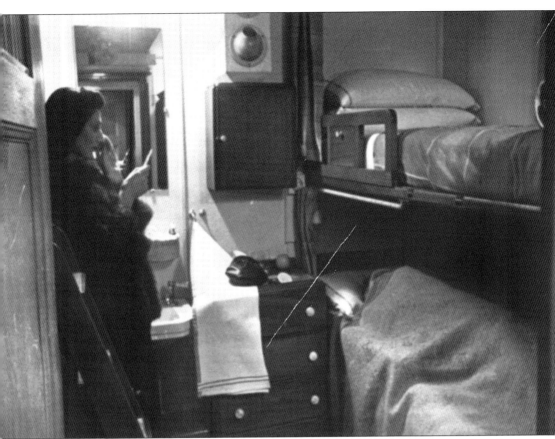

Most newsmen focused on first class luxury, but a story picked up by many newspapers enthused, "third class today corresponds to the old steerage, but there the relationship ends. It is a far cry from a wire spring on which an immigrant threw his own mattress to inner spring mattresses on mahogany beds, reading lamps, electric fans, fitted dressing tables, luggage space and passenger controlled air conditioning." Some writers thought third class had more fun than the first class passengers who stayed behind their stateroom doors until nightfall. In 1957, John B. Crane commented, "The tourist class passengers . . . are of quite a different breed. They take an ocean voyage, not to escape from their fellow creatures, but rather to have fun, to see and be seen, to dance, drink and wander around the ship exploring eagerly the labyrinth of passage ways, staircases, lounges and bar rooms. . . . If there is one thing a tourist passenger fears, it is being alone and forced to lie in solitary confinement in his tiny bunk away from all the fun."

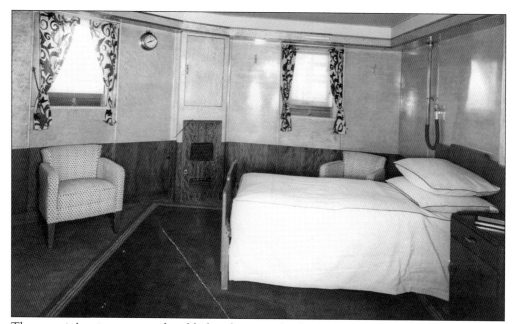

The captain's suite was comfortable but functional. The bedroom was reasonably roomy for shipboard accommodations and had several curtained portholes. His dayroom included sitting and working space. When Capt. Treasure Jones brought the *Queen Mary* into Long Beach, his wife, Belle, traveled with him. He revealed to the press that she was not a good sailor, and it was only her second voyage.

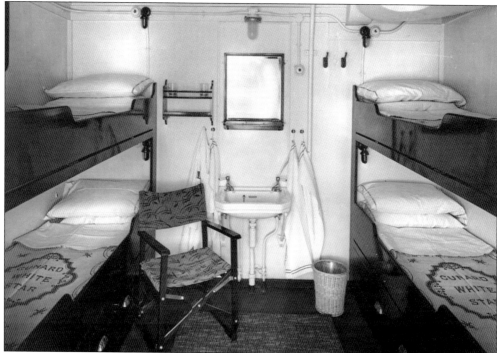

The crew's quarters were more cramped and had no exterior view. This cabin slept four in bunks with storage drawers built in. The rather Spartan accommodations included a chair and shared sink.

Five

ACTIVITIES

In August 1939, third class passengers could take advantage of a full range of activities. On Thursday, August 10, sign-ups for a ping-pong tournament began at 10:00 a.m. Activities included horse races, keno, music, and dancing in the Garden Lounge. The cinema offered *Dodge City* with Errol Flynn on Thursday; *The Modern Miracle* starring Don Ameche, Loretta Young, and Henry Fonda on Friday; Bette Davis in *Juarez* on Saturday; and *Made for Each Other* with Carole Lombard on Sunday. Sunday also featured a divine service and a children's tea party. Also proposed was a concert, and passengers were kindly requested to watch the blackboards for additional activities and announcements.

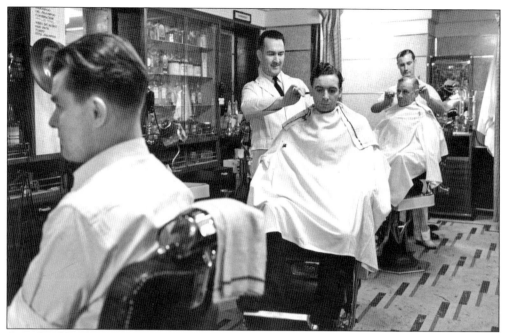

On a ship like the *Queen Mary*, being seen by others could be as important as seeing new places. Gentlemen in first class could get a shave and haircut in their own barbershop, set apart from the salon where their wives and daughters were having their hair styled. Men and women in second and third class were beautified in less elaborate shared facilities.

While the ship was under construction, films advanced from silent to sound, so the third class cinema, like that of the other classes, was installed with the latest projection equipment. Behind the screen was a raised platform for concerts or theatrical productions, with dressing rooms for the latter. When not in use as a theater, the stacking chairs would be removed and the room refurnished as a lounge.

Dressing well has always been a favorite sport among young women. These lovely college girls were immortalized by one of the ship's roving photographers. The *Queen Mary*'s red, white, and black color scheme showed up frequently in onboard sportswear. For a more subtle statement, a lady could wear Queen Mary Rose, a salmon pink created by Margaret Hayden Rorke. The color was launched in cooperation with Cunard.

The glass-enclosed Promenade Deck was a good place to spot the latest in shipboard fashion. Although the RMS *Queen Mary* inspired her share of clothing, there is no record of whether it was actually worn aboard. British fashion designer Reville designed a dress in navy crepe with diagonal lines of white spelling "Queen Mary." Prince Andrew of Russia designed a pocketbook with three funnels forming the handle.

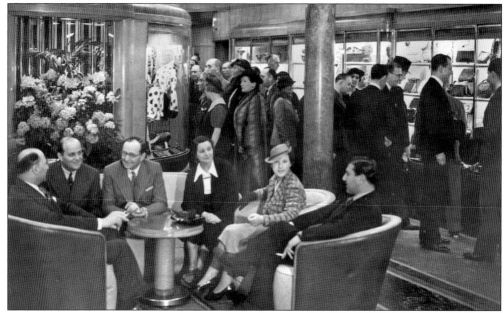

Shopping has always been a social activity as much as an opportunity to purchase something beautiful or useful. The shops on the Promenade Deck offered first class passengers an opportunity to buy a newspaper, find a new frock, or simply browse with friends. The 50-foot ivory plaster frieze by Maurice Lambert, entitled *Sport and Speed*, depicts athletes, gazelles, and aircraft speeding over the shoppers, propelled by the artist's disembodied hands.

One woman who ran gift shops on the *Queen Mary* met many Americans before the war, but as a cipher clerk in the Woman's Auxiliary Air Force, Marjorie Allen admitted she was amazed at how the fliers kidded each other. "I always take anything they say with a large lump of salt." She also said, "I like Americans. I like American cigarettes and American food. And rum and Coke."

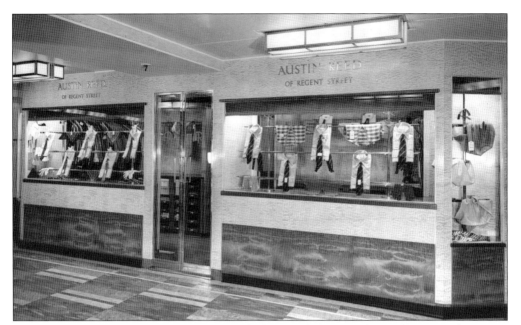

By the 1930s, London clothier Austin Reed had expanded into a chain offering ready-to-wear suits. The second class shopping area featured their ocean-going outpost. During World War II, Austin Reed's handiwork could be seen in uniforms worn by male and female soldiers, as well as Winston Churchill's famous siren suit, a one-piece jumpsuit designed to zip quickly over pajamas during air raids.

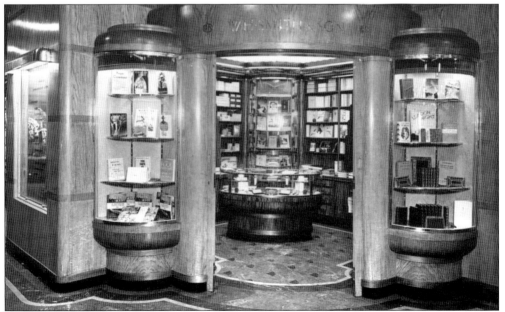

Finding bookseller W. H. Smith aboard an ocean liner was no surprise. The business had pioneered the idea of bookstalls in railroad stations as early as 1848, selling newspapers and popular books to travelers looking to lighten the tedium of a journey. As travel changed, the operation was expanded to ships and airports. Since 1959, the company has also sponsored the W. H. Smith Literary Award.

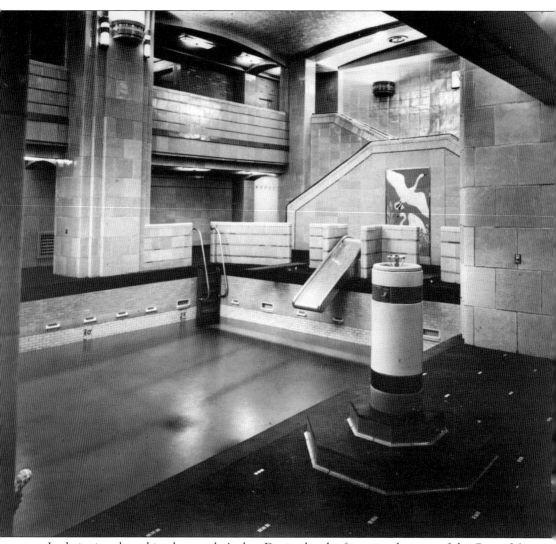

In designing the cabin class pool, Arthur Davis, the chief interior designer of the *Queen Mary*, drew heavily upon his work on the Pompeian Bath for the Royal Automobile Club in Pall Mall, which he completed in 1911. The bi-level layout, with its grand entryway, was not only visually striking, but also helped to alleviate the restrictions posed by the distance between two decks. The ceiling was finished in artificial mother-of-pearl for a trompe l'oeil sparkle that simulated sunshine. The pool, located on D deck, was open year-round and in all weather, although in rough seas, jumping or sliding into the pool required swimmers to pay particular attention to the rolling of the pool water. The pool water would slosh back and forth, like a bathtub, and many a passenger came close to landing on an almost dry pool bottom before the water surged back.

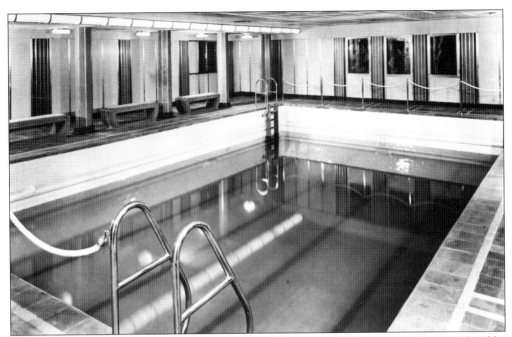

Although first class held every luxury available on the sea, second class was nearly as comfortable. The idea of amenities like an elegant blue-and-silver swimming pool for second class passengers was a relatively new one. Glass panels by Charles Cameron Baillie showed angelfish lazing among the seaweed. Three surviving panels are still displayed onboard, but the pool itself was demolished.

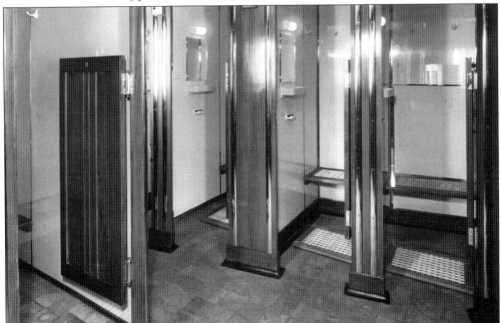

Dressing rooms allowed passengers to don a bathing suit in privacy. There were 10 cubicles for gentlemen and 12 for ladies near the second class pool. Ghost hunters claim that the first class dressing rooms are a vortex of spectral activity, but since the second class pool has been removed and is now used for storage space, second class spirits will have to be upgraded to first.

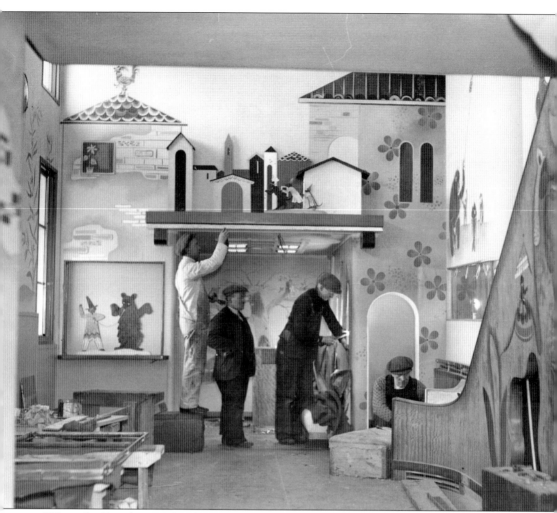

When the British royal family came to bid the ship bon voyage, the *New York Times* reported that Princess Elizabeth, in gray tweed and a mauve straw hat, "was the most excited of any of the visitors, particularly in the children's nursery, where she shouted with glee over an animal film, made several trips down a slide, played the toy piano and used a toy telephone." She obviously agreed with *The Shipbuilder and Marine Engine-Builder*, which described the soundproofed room with washable walls as "one of the most fascinating children's playrooms ever devised in any ship." Other delights included a brightly plumed parrot watching over three caves hidden under the slide, a dollhouse, a log cabin, and a small aquarium with tropical fish. The murals and decorations by George Ramon were removed during the 1967 conversion.

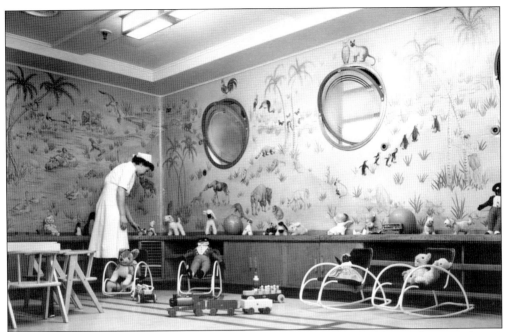

Although not quite as elaborate as first class, the second class playroom featured illuminated caves under the tracks of a model train speeding around three walls. Herry (Heather) Perry, who painted the murals of Noah's Ark, specially designed the toys for the room. She illustrated several books for children. Perhaps there was also a copy of *Animals Limited*, a book she illustrated about a zoo.

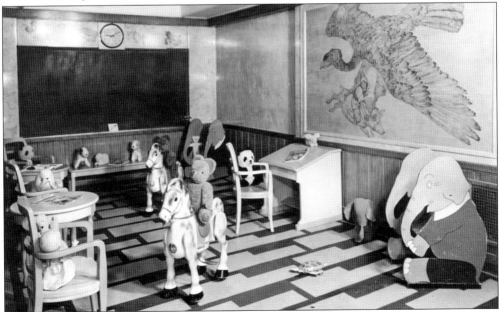

Charles Cameron Baillie's graphic illustration of Sinbad seems like an invitation to nightmares, but the tales of the *Arabian Nights* were thoroughly familiar to children of the day (who were, like children today, more bloodthirsty than their parents would prefer). The third class nursery mural shows the resourceful Sinbad escaping from an island by tying himself to the leg of the roc, a monstrous bird, using fabric unwound from his turban.

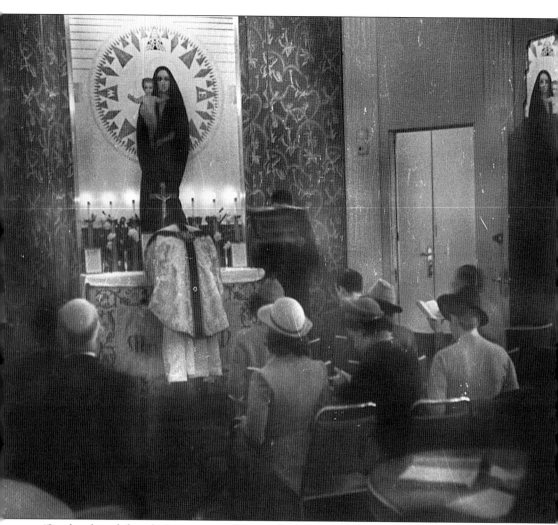

"I rather feared that the innovation of giving the Madonna and Child a sea-faring interest might not be approved," said artist Kenneth Shoesmith, "but as it happened, they were delighted." The panel was covered with a mosaic of gold leaf to withstand the rigors of sea air, but the greatest challenge was keeping the details correct. Father Hurley, the port chaplain at Southampton, gave ecclesiastic approval, but Shoesmith probably cared more about the sextant at the feet of the *Madonna of the Atlantic* than the papal keys in her halo. He admitted, "Familiar as I am with navigating instruments, I never draw them from memory. Seamen and old travelers are the severest critics of technical details in maritime matters; they would be especially hard on inaccuracies committed by an ex-sailor." Chapel attendance was rarely overwhelming in first class. Many passengers skipped church while on vacation, but others considered Mass aboard an ocean liner an interesting experience or perhaps a chance to pray for a smooth crossing. A screen covered the Madonna when the room reverted to its secular purpose.

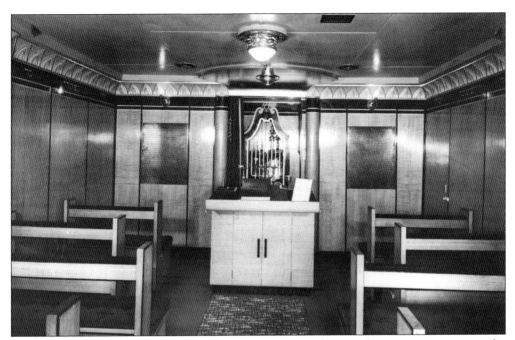

Although other ships, including the *Normandie*, converted rooms for use as a synagogue, the *Queen Mary* was the first to have one included in the original design. Consecrated by Dr. J. H. Hertz, chief rabbi of the British Empire, the room was designed with Hebrew inscriptions inlaid around the top of the paneling. The ship also had a kosher kitchen.

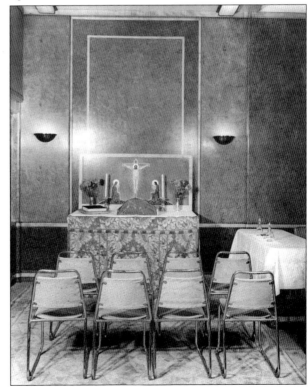

Passengers traveling third class were often emigrating, and given the uncertainty of their futures were, perhaps, a bit more devout than those in first class. Ministerial services were usually provided by clergymen who were aboard as passengers, and if none were available, an officer or a member of the purser's staff filled in.

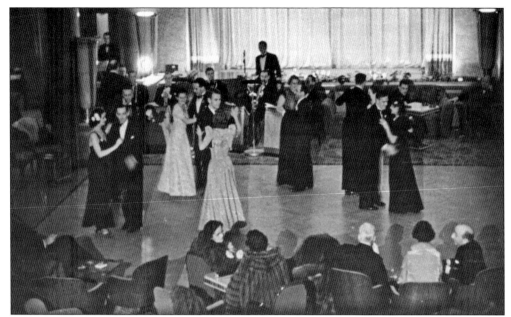

Unlike modern cruise ships, organized passenger activities were not part of shipboard life, with the exception of dances. Following the lead of the best hotels on land, the daily dances were highlights of the cruise for many. The ship maintained a regular band, which performed daily for tea dances, cocktails, and after dinner, when the Wilton carpet in the first class lounge was rolled back nightly to reveal a parquet dance floor.

Passengers in first class may have felt a need to maintain a facade of sophistication, but the other classes had the freedom to take their enjoyment where they found it. Funny hats and games were used to break the ice at parties. Whatever the rules of this game with a balloon, it offered a superb opportunity for an attractive young man and woman to get close to one another.

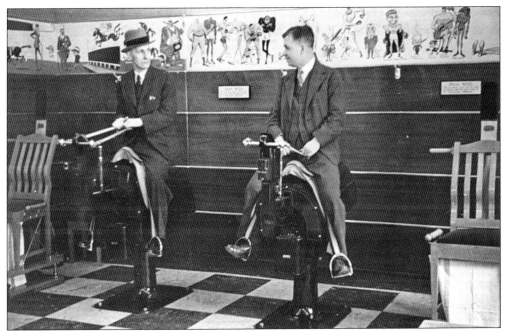

Gym attendant Kenneth McLean gave passengers an active start to the day in 1936 with exercises on the Sun Deck. Other patrons preferred to let the electric horse or camel-riding machine do the work while they read the newspaper or chatted. The walls of the gym were lined with caricatures of notable sports figures by Tom Webster, the sports cartoonist for the *London Daily Mail*.

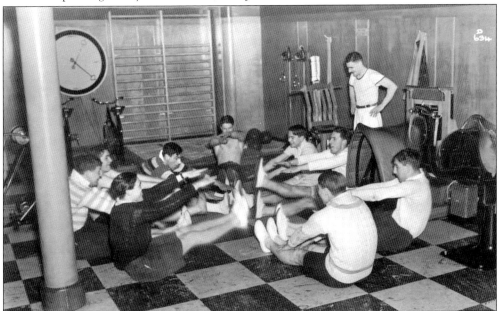

Gym patrons were more likely to be businessmen than athletes, McLean opined, because athletes were glad of a break from routine, but deskbound businessmen felt cheated with no exercise during the voyage. It seems the Cambridge squash and rugby teams disagreed—or their coaches did—since they took advantage of the second class gym to prepare for their games against Yale and New Haven in 1938.

Without a track, real horses may have had a problem racing at sea, but passengers happily gambled on wooden cutouts propelled by the numbers on dice. Programs gave equine names and parentage: "Romance, by Passenger out of Voyage," or "Ptomaine, by Oyster out of Season." Rules strictly forbade any judge from disqualifying a horse so his own could win, and 10 percent of the proceeds were designated for maritime charities.

In spite of the often brisk temperatures of the North Atlantic, the *Queen Mary*'s Sports Deck was a favorite area among passengers looking for a breath of fresh air and a little physical activity. The ship offered a surprisingly wide selection of "court" sports; there were squash and racquetball courts, as well as four deck-tennis courts, three fore and one aft, just in front of the Verandah Grill. Deck tennis was a variant of tennis peculiar to ships, which used quoits (a heavy rope ring) instead of a tennis ball in order to lessen the number of projectiles that rolled into the drink during a vigorous game. Quoits (played as a ring-toss game) and shuffleboard were popular, particularly with women and mixed groups, since they relied on skill rather than speed, and the ability to keep one's footing between swells, as was the less physically demanding sport known as the "daily tote," wherein passengers wagered on how many miles the ship had traveled.

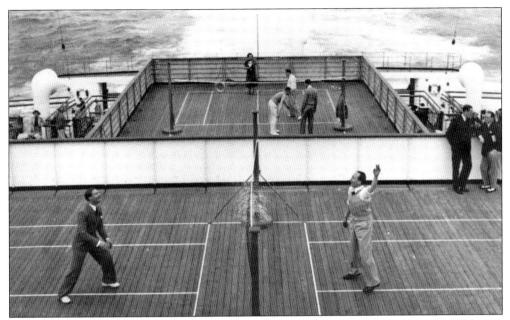

Sportswear changed significantly between the *Queen Mary's* first and last voyage. In 1936, men wore jackets and ties for deck games, and well-dressed women donned smart sport frocks. By the final voyage, the dress code was far more causal. Formality was expected only at dinner, not while golf pro Frank Makepeace tried to correct a swing as the ship swayed.

The class system for passengers aboard the *Queen Mary* was as apparent on the Sports Decks as it was elsewhere aboard. The four tennis courts were off-limits to third class passengers. Still, third class passengers could pass the time by playing shuffleboard or strolling in the brisk North Atlantic air. After World War II, Cunard reassigned one tennis court for the use of third class passengers, by then rechristened as the "tourist class."

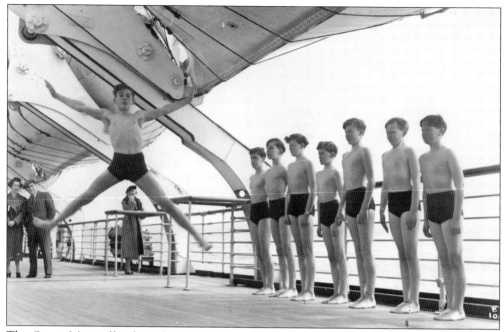

The *Queen Mary* offered ample opportunities for amusement, no matter what the passenger's age and energy level. Some groups enjoyed shipboard life more vigorously than others. Watching the boys from Belteshanger School would have provided an hour's worth of amusement for more sedentary passengers.

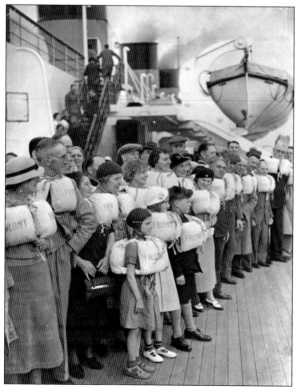

Mandatory lifeboat drills on the *Queen Mary* took place the first full day the ship was at sea. With steel hulls and motors that could propel them through the water at a speed of 6 knots, the 24 boats could carry a total of 3,266 people—more than the passengers and crew combined—and could be launched single-handedly in less than a minute.

A pet owner may have been somewhat leery of leaving Fluffy in the care of the chief butcher, but the Cunard title for the kennel master dated to a time when cattle were carried aboard ships to provide milk and meat. Dogs aboard the *Queen Mary* traveled in luxury, too, with blankets and a daily leashed walk on the deck. They were not, however, allowed to share quarters with their owners.

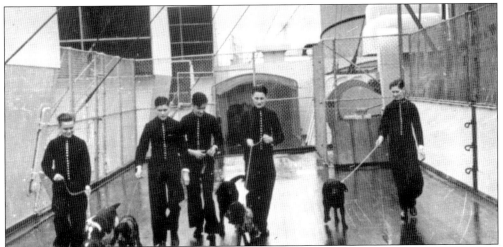

Kennel masters agreed that pet owners were generally more troublesome than their dogs. Joan Crawford abruptly switched ships when she found out that her toy poodle, Chiffon, would have to suffer the indignity of a kennel. Most dogs, though, did fine. Pampered pooches, including the Duke and Duchess of Windsor's pugs and Asta from the *Thin Man* movies, emerged safe and sound at journey's end. The kennel housed seagoing felines, too.

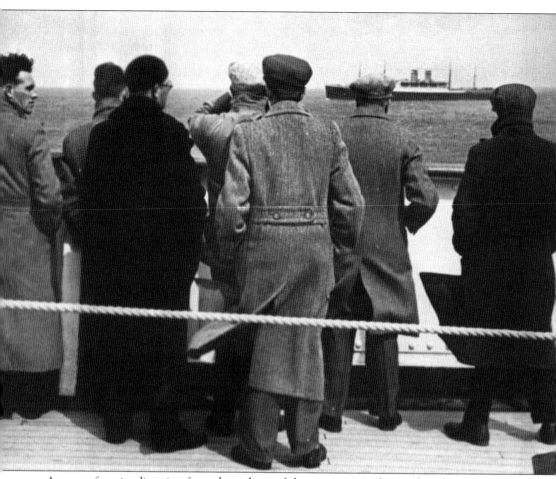

At sea, a favorite diversion from the tedium of the waves is watching other ships pass. Pictured here, passengers contemplate the Hamburg Amerika Line's *Deutschland IV* during the lead-up to World War II. When this picture was taken, the commodore of the *Queen Mary* ordered the ensign dipped to salute the German liner, but the *Deutschland* did not return the salute. The *Queen Mary* was the faster ship, and she passed the *Deutschland* in record time. In 1945, the *Deutschland* paid the ultimate price for wartime service when she was sunk in an air attack at Lubeck. The *Queen Mary* was one of the few grand ocean liners to survive the war.

Six

THE GREY GHOST

With war in Europe, speculation was rampant about the fate of the three great ocean liners. Harbor security was tight. Jane Cobb joked in the *New York Times* that "any one, no matter how dull and unglamorous his personal life may be, can feel the pleasant glow that comes from being suspected of being an international spy." Another *New York Times* writer saw melancholy in the *Queen Mary*'s ghost-gray paint. "The *Normandie* and the *Queen Mary* are the most tragic vessels: the two great queens of the Atlantic, formerly too proud to be admired together, now lie meekly side by side at the foot of Forty-ninth Street, one of them smeared with dingy paint that would break the heart of a beauty." That beauty was the only one to make it to old age. The elegant *Normandie* died in the Hudson mud, the victim of a spark from a welding torch during conversion to a troopship. The lovely *Queen Elizabeth* made it safely through the war but was lost to fire in Hong Kong Harbor in 1972.

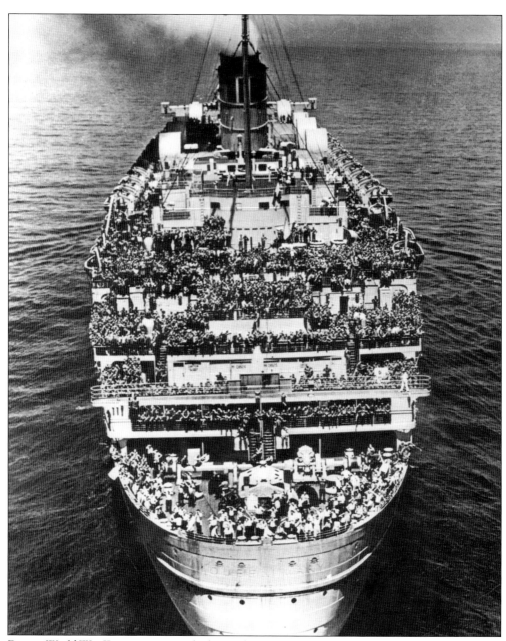

During World War II, troops were packed onto the *Queen Mary* in numbers that made sardines look comfortable. With 15,000 men, plus a handful of women, aboard, traffic control was imperative. Every possible space, including the swimming pool, was filled with tiers of steel and canvas bunks. Men slept in shifts, with their meal times designated by red, white, or blue buttons. What may have been most astonishing was how little graffiti they left, with the exception of names carved on the outer rail or penciled on the bottom of drawers. It was tribute, perhaps, to the *Queen Mary*'s beauty and courage. The troops she carried turned battles. She remained serene. The Italians boasted they torpedoed her. They did not. Hitler offered a reward to any captain that could sink her. It was never paid. She zigzagged through U-boats, and rode out massive waves, coming through the war years safely with her dignity intact.

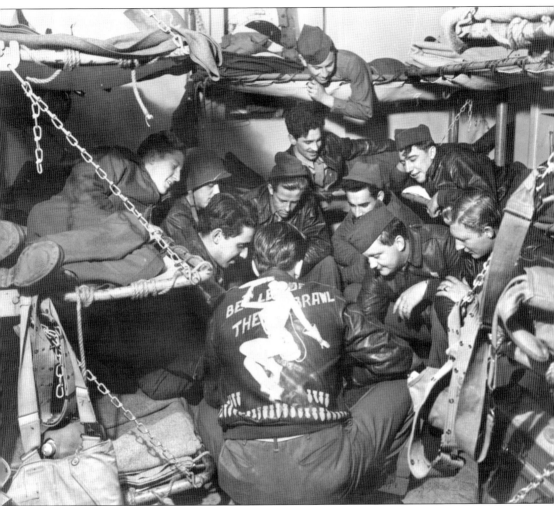

During the war, cabin class staterooms took on a decidedly third class air, with levels of bunk beds hanging from every available vertical surface. These luxurious rooms, which had previously provided ease and comfort for two, could accommodate 21 sleeping men spaced a mere 18 inches apart. As the demand for troops increased, the *Queen Mary* was subjected to near constant refits to increase her passenger capacity. Three-tiered berthing became six-tiered, and three men sleeping in shifts were assigned to each bed. A rotation was put into place so that those sleeping below decks would switch with those sleeping on deck twice during the passage. Meals, too, were served in rotation, as did the kitchen staff who prepared them.

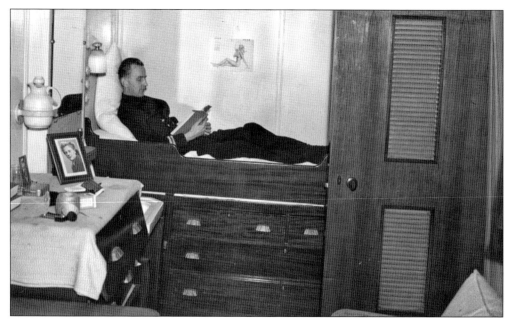

Officers enjoyed more privacy than enlisted men. This officer's lodgings, originally a third class or crew cabin, displays a framed photograph of the girl he left behind on one side and his idealized pinup girl on the other. One of the more onerous hardships for officers was that during wartime, the ship was officially dry. Any liquor, including an officer's afternoon glass of sherry, would have to be smuggled aboard.

Herry Perry's whimsical murals make an ironic background for officers who adapted the second class playroom for their own use. Where small boys played with toy soldiers, these men worked on the deadly serious business of defeating Hitler.

During World War II, the Wrens (Women's Royal Navy Service) took over the responsibility of staffing the *Queen Mary*'s communication office. Prior to 1941, the Wrens mostly served on land, doing clerical and driving duties to "free a man for the fleet." Manpower shortages following that date found the Wrens assigned various important duties onboard royal naval vessels, although mostly in port rather than at open sea.

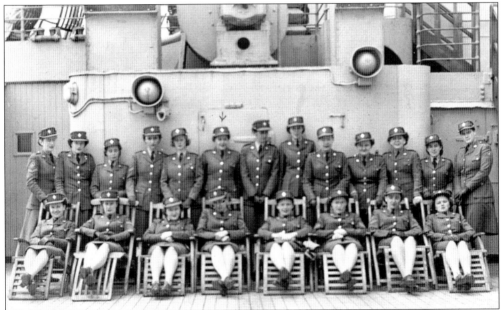

Between the Army Nurse Corps, Canadian Women's Army Corps (CWAC), and the Women's Army Corps (WAC), more than 200,000 women served in World War II. Although the women were not generally allowed in active combat and served primarily stateside, as the war intensified some were sent overseas, and General MacArthur called the WACs his "best soldiers." Army nurses served under fire in field hospitals in some of the worst battles of the war.

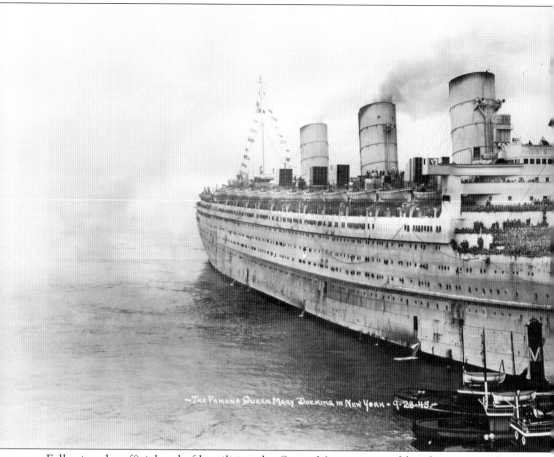

~The Famous Queen Mary Docking in New York · 9·28·45~

Following the official end of hostilities, the *Queen Mary* continued her ferry service between Europe and the United States, this time carrying home the thousands of soldiers she first brought to war. Here she arrives in New York Harbor on September 28, 1945, carrying a staggering 15,130 soldiers and crew. Her arrivals in New York were always joyous affairs, rivaling New Year's Eve celebrations, as the families and friends of returning GIs lined the docks to wait their arrival. This also began the *Queen Mary*'s slow return to civilian life—beginning first with the repainting

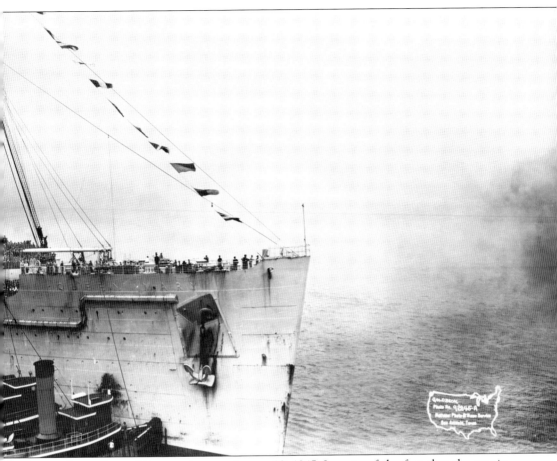

of her stacks in Cunard livery colors on August 29, 1945. In spite of the fact that the war in Europe was officially over, she kept her guns and her anti-mine equipment (the long pipe seen here) due to concerns of stray U-boats until her last voyage as a troop ship. By September 1946, she was back in Southampton and beginning her refit. (Courtesy of Chuck Kovacic and Athene Mihalakis Kovacic.)

After a crowded, weary voyage, many a soldier left his mark on the railings. When the ship completed her wartime duties, it was emblazoned with initials, hometown names, and other souvenirs carved by soldiers on their way to fight in Europe. Some former GIs were disappointed to find their initials gone and signs of their heroic service erased when the rail was replaced during postwar refurbishing.

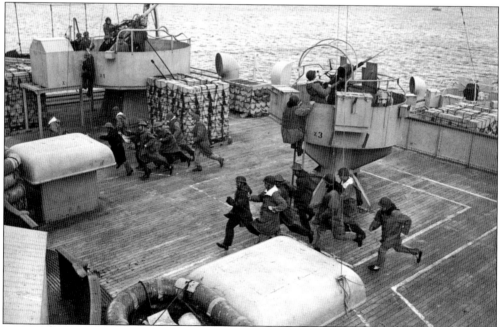

During the war, the temporary gun crews on each voyage of the *Queen Mary* were drilled daily during the first watch, and often on night watch as well, in order to assure that the ship remained ready in case of attack. Two antiaircraft emplacements were erected on the games deck just aft of the Verandah Grill, and escort planes were used as practice targets for aiming the guns.

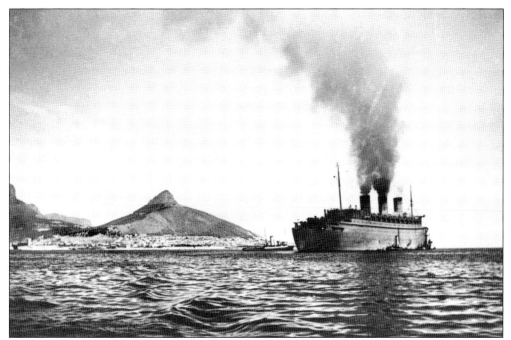

From the time she slipped quietly out of New York Harbor clad in ghostly gray, news of the *Queen Mary* was strictly censored, but rumors still surfaced. She was reportedly seen loading Australian troops, spotted off Hong Kong, or anchored at Capetown. A fortunate combination of speed, smart navigating, and camouflage, as well as images of her seeming disappearances into ocean fogs, earned her the name "The Grey Ghost."

In her five years of military service, the *Queen Mary* never suffered any serious damage, and in fact, never encountered a single German U-boat; was never fired upon from the air, sea or land; and never fired a single shot in battle. Her remarkable record only surfaced after the war, when the possibility of betraying her position to the enemy was well past.

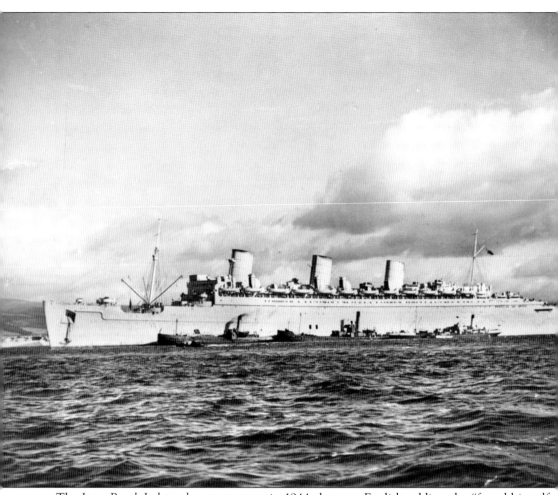

The *Long Beach Independent* ran a story in 1944 about an English soldier who "found himself clinging to a raft in high seas" when his ship was torpedoed by a German submarine. "As he lay there, the *Queen Mary* came by. Its commanding officer sent this message to the almost drowned victim: 'Sorry Cannot stop! Will report your position.' The father of the stranded British Tommie happened to be the chief engineer of the *Queen Mary*. When he visited his wife after this particular trip, he had the pleasure of reading the following in a letter his son had sent to his mother: 'Our ship was torpedoed and sunk by the Germans. We drifted on a raft for several days while awaiting rescue. Then there came into our distracted view, the good old *Queen Mary*, and we knew that we would be saved. But the chief engineer, my useless father, would not stop to pick us up. Why don't you get a divorce?' "

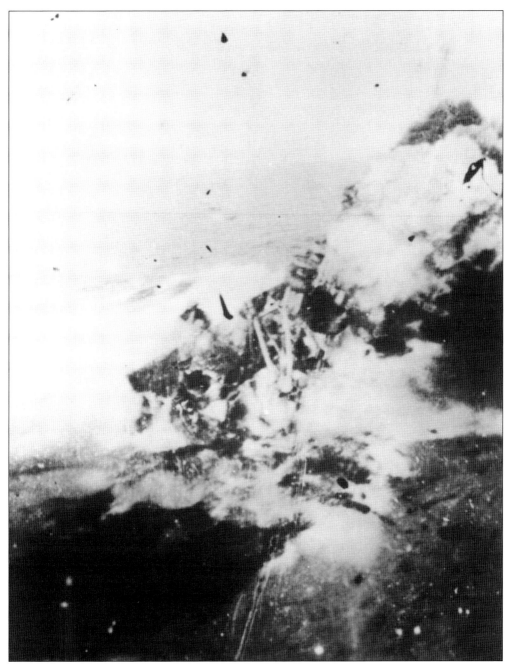

In September 1942, the *Queen Mary* departed New York carrying an astonishing 10,308 American troops across the Irish Sea. On October 2, as the *Queen Mary* approached Scottish coastal waters, the HMS *Curacoa* was sent out as escort. The captain of the *Curacoa*, realizing that his ship was considerably slower, signaled the *Queen Mary*'s master that he would "edge in astern of you." Tragically, less than two hours later the *Curacoa* was sliced in two as the *Queen Mary* ploughed through her hull and sent 329 of the *Curacoa*'s crew of 430 to the sea's depths. News of the accident was suppressed, ostensibly because it could be used by the Germans as propaganda, but more probably to protect Allied troop morale.

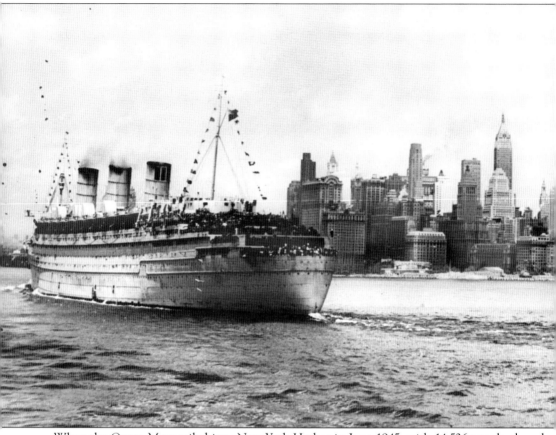

When the *Queen Mary* sailed into New York Harbor in June 1945, with 14,526 people aboard, the greetings were raucous. The Germans had surrendered, and every porthole was filled with soldiers and nurses celebrating their return home. One golden-haired nurse was a sensation with the crowd as she waved "a strictly unsoldierly pair of black lace panties," said the *New York Times*. "Hey," the blonde girl cried, "We won," although another nurse officer remarked with asperity, "She is not in our outfit." By then, the *Queen Mary* and *Queen Elizabeth* had ferried 1,243,538 soldiers across the Atlantic to fight. The returning tide came in waves of 11,000 to 15,000 aboard on every trip. Not that the soldiers were complaining. One man interviewed by Bill Cunningham crowed, "It was tougher than this last winter, Mister, and whatever else it is, this is the fastest way HOME."

Following the end of the war, the *Queen Mary* made 13 voyages and carried more than 20,000 war brides and their children to rejoin their GI husbands in the United States and Canada. Decks that had been crammed with impossible numbers of GIs were now filled with mothers pushing perambulators in the brisk North Atlantic air. For these new British expatriates, New York Harbor was their first sight of their new home.

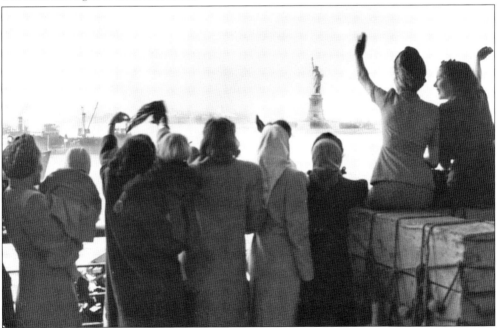

The Statue of Liberty greeted the war brides with open arms. Although the women were "resolute enough to chance a life in a new land," reported the *New York Times*, old ties were hard to break. "At the dock in Southampton they sang 'There'll Always Be an England.' But dressed in their best and lined up at the rail in New York Harbor yesterday they sang 'The Star-Spangled Banner.' "

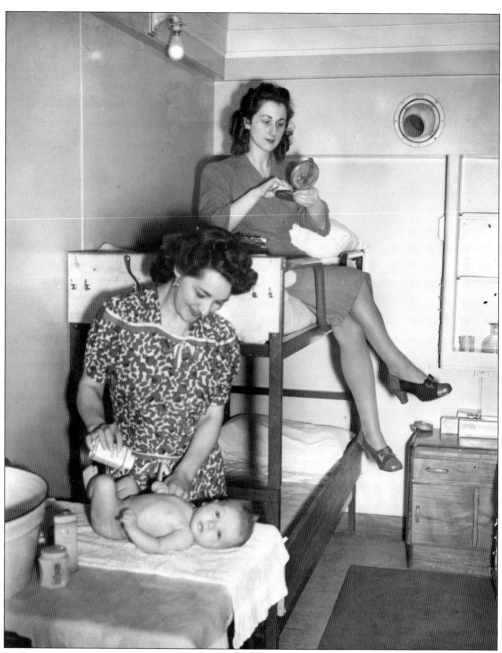

In the late 1990s, the *Queen Mary* began an oral history program, beginning with the memories of the war brides. Some recalled storms and sea sickness, but they retained a fondness for the ship that carried them to their new husbands. They recalled that their babies slept in netting beds attached to their mother's bunk. There were classes for the women onboard, and they were given yarn and knitting needles. Some volunteered to work on the ship's newspaper, and one woman recalled that the passage was so rough that the paper carried the headline "Battered Brides." News reports at the time also told of diapers drying in the swimming pool, specially made baby lifebelts hanging from cots, and highchairs scattered throughout the ship where weary mothers could safely seat their toddlers.

Before they left England, the Red Cross offered a deglamorizing school to counteract expectations raised by Hollywood films and bragging hubbies. These brides may have learned how to shop for groceries in the United States, but they seem to have had more exuberance than common sense—even from the lowest portholes, it was a long way down.

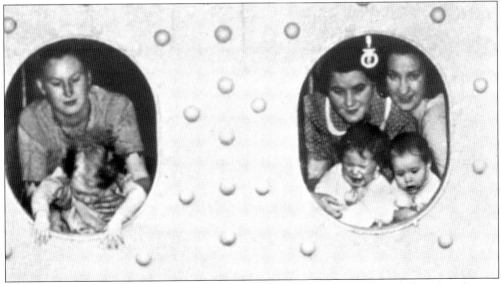

Mothers sensibly kept their children safely behind the portholes. Some babies found many godfathers. In January 1946, the 82nd Airborne stood up en masse when triplets were christened in the captain's cabin, the first baptism on the ship since the war started. Their mother said that everyone on the ship was wonderful to her, but no one volunteered to help wash diapers.

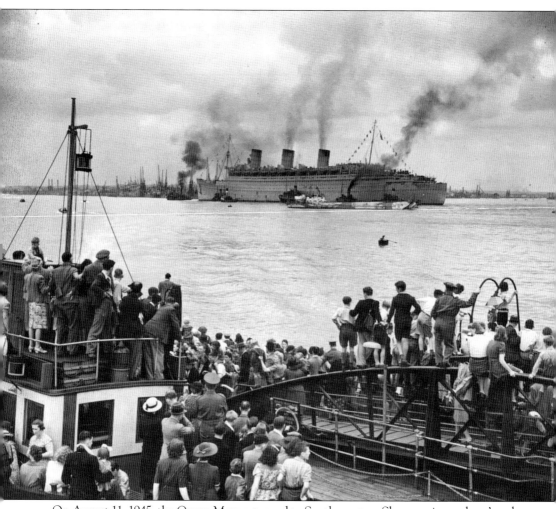

On August 11, 1945, the *Queen Mary* returned to Southampton. She was given a hero's welcome, and the din of whistles rivaled her greeting in New York on her maiden voyage. In honor of her wartime service, the band played "The Star Spangled Banner." Bombers roared overhead, and thousands of people lined the shore and docks. It was a sentimental occasion. After six years of war duty, she was finally home. The Lord Mayor of Southampton headed an official delegation to welcome her. Not that her work was done—she still had at least a year of gales, close encounters with mines, getting the Yanks home, ferrying war brides to a new life, and, of course, allowing Winston Churchill to make several more transatlantic trips, before her ownership reverted to Cunard. In 1946, she went home to primp before her second debut as a luxury liner.

Seven

ART AND ARTISTS

It is not surprising that Lady Kennet was chosen to sculpt a bas-relief of the ship's namesake, Queen Mary. She began her career in art under the tutelage of Auguste Rodin in Paris. Her obituary noted that she was "one of the finest symbols of emancipated post-Victorian women," with a considerable reputation as a sculptor of well-known men, including her first husband, Capt. Robert F. Scott, leader of the ill-fated expedition to Antarctica. Her last letter to him was full of comforting words about Amundsen beating him to the pole. She was on a ship bound for New Zealand to meet him when word came of his death. In 1914, she helped organize an ambulance service to cooperate with the French Army. Her 1922 marriage to Edward Hilton Young (later given the title of Lord Kennet) lasted until her death, but she continued to sign her work "Kathleen Scott."

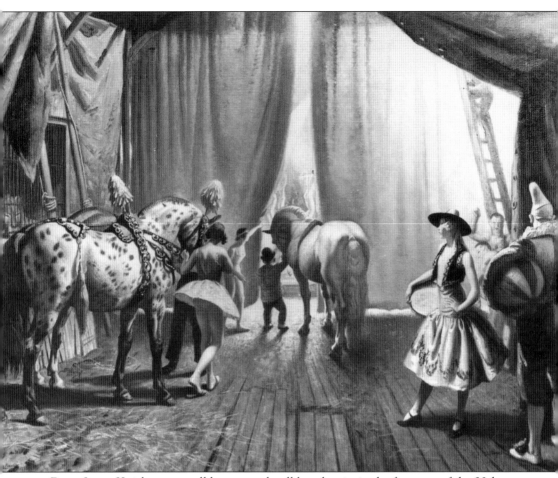

Dame Laura Knight was a well-known and well-loved artist in the first part of the 20th century. She was brought up in poverty after her father's death, but her mother, a talented amateur who taught painting, inspired her daughter with her love of art. "I learned how to lisp in art . . . if I wasn't born in the studio, I grew up in it," Dame Laura remembered. Among her favorite subjects were the circus, racetrack, and dancers. In the 1920s, she received permission to work backstage at Diaghlev's Ballets Russes, where she learned to draw quickly and, above all, accurately. If the lines were wrong, the famous ballet instructor Cecchetti would blame the dancer rather than the painter. In 1929, she was made a Dame Commander of the British Empire, the first female artist to receive the honor. After World War II, she was commissioned to paint the Nuremberg Trials. After the death of her husband, artist Harold Knight, in 1961, she was less prolific but continued painting until her death at 92.

The Gilberts were one of the artistic families that worked aboard ship. The bronze doors designed by Walter Gilbert and his son, Donald, are simultaneously refined and massive, with stylized waves and mythological creatures of the sea. Daughter Margot painted the history of dance for the ballroom.

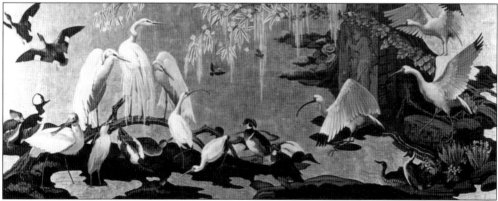

Artists and art critics complained that challenging, modern work was excluded from the *Queen Mary*. No doubt this was due to conservative corporate tastes, but on a rough North Atlantic crossing most passengers would have preferred the comfort of A. Duncan Carse's lovely birds against a silver-leaf sky to something revolutionary. *Birds of the New World*, with *Birds of the Old World*, are still in the first class dining room.

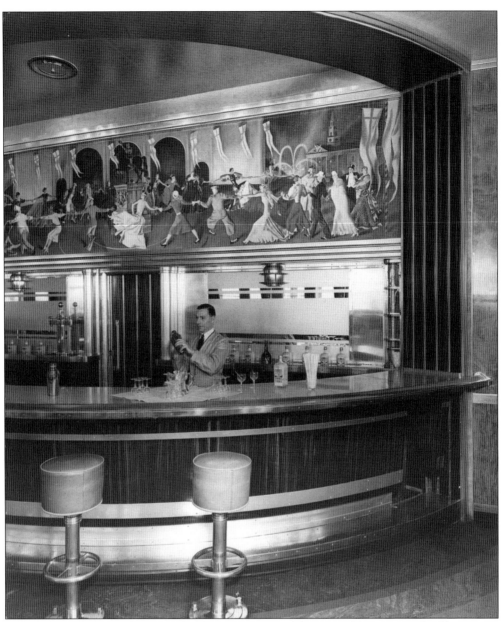

The exuberant dancers celebrating the silver anniversary of the reign of George V in the Observation Bar seem to be cavorting to music their creator would not have been able to hear. Painter Alfred R. Thomson was born deaf. His father thoroughly disapproved of his interest in art and placed his son on a farm to learn agriculture with the specific instruction that he was not to be allowed any art supplies. Alfred ran away two years later to begin the process of establishing himself as an artist. He became known for his caricatures, including flamboyant drawings of characters from Dickens covering the walls of a pub. He eventually branched out to more serious work as well. After the Royal Air Force disqualified him from service, he became their official artist. "As if to prove the point," Bonnie Meath-Lang wrote in her book about deaf artists, "Thompson was shot by a sentry on base when he did not hear the order to identify himself. The bullet was not removed so his arm would not be paralyzed." He continued to paint until his death in 1979.

Although his most famous work was a portrait in oils of his friend D. H. Lawrence, South African artist Jan Juta felt there was a natural affinity between glass and metal. He worked his canvas of glass with a tool like a dentist drill, metallic paints, sandblasting, or acid etching to create the large, illuminated panels depicting myths of the sea.

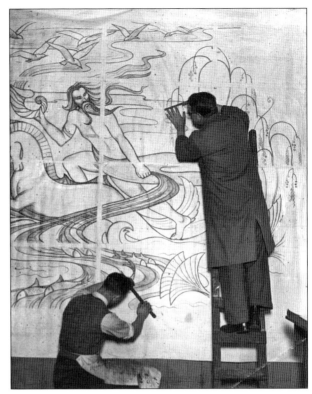

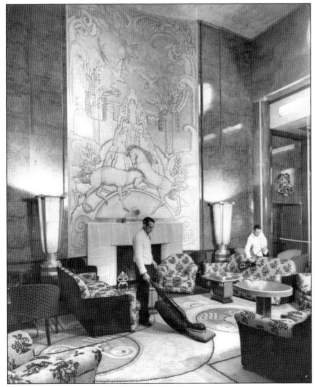

The carved gesso panel, gilded in silver and gold, behind the steward vacuuming some of the ship's miles of carpet, is by Alfred J. Oakley and Gilbert Bayes. Bayes's most prestigious artwork was much smaller than the enormous *Unicorns in Battle*. Every British monarch has an individual seal, and George V's was designed by Gilbert Bayes. Hidden behind the unicorns is the equipment to turn the room into a cinema.

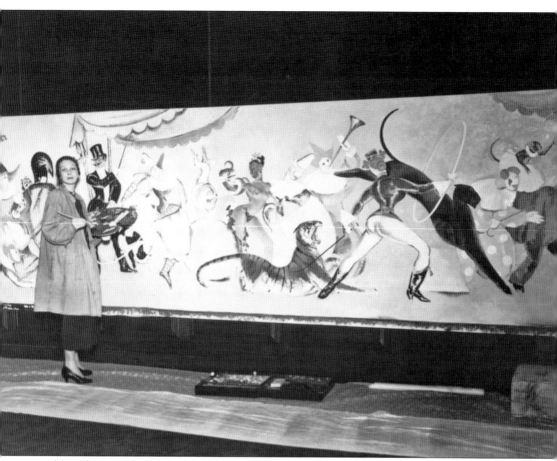

Although Cunard officials were scandalized when Doris Zinkeisen insisted on a plain black carpet for the Verandah Grill, the theatrical instincts that led her to become a costume designer served her well. The intimate space could rival the captain's table as a sign of social status. Her 30-foot mural, *Entertainment*, brimming with performers from the theater, ballet, circus, and nightclub, set the scene for dancers and diners alike. Not all the painted figures expressed a joyous verve for life, however. It was said that one bosomy dowager shown staring disapprovingly through her lorgnette had to be modified after Edward VIII stopped in front of it and exclaimed, "Oh, dear, how like mama!"

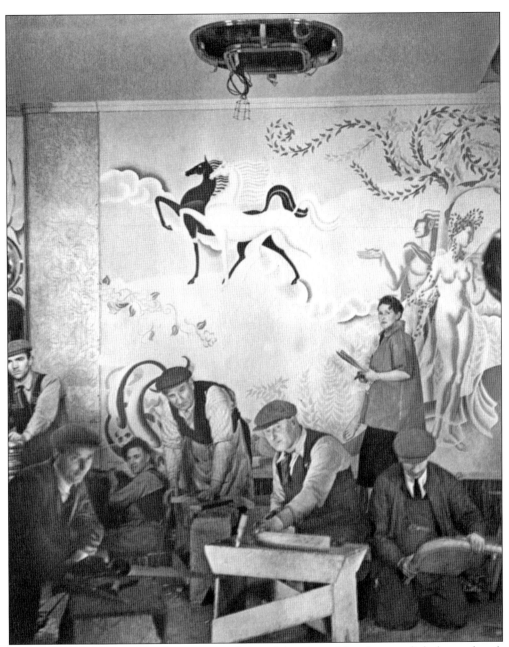

Like her sister Doris, Anna Zinkeisen painted aboard the *Queen Mary* far more light-hearted work than their difficult World War II contributions. Doris, the official artist for St. John's Ambulance Brigade, painted the concentration camp Bergen-Belsen just after liberation. Besides nursing at St. Mary's Hospital, Anna's medical drawings of injuries and disease, painted in an unused operating room, have been used to educate doctors. Anna was also noted for her illustrations for children's books. Their children obviously inherited their artistic talents. Paintings by both sisters were featured in a 1975 art exhibit, along with work by Doris's twin daughters and Anna's daughter and son-in-law.

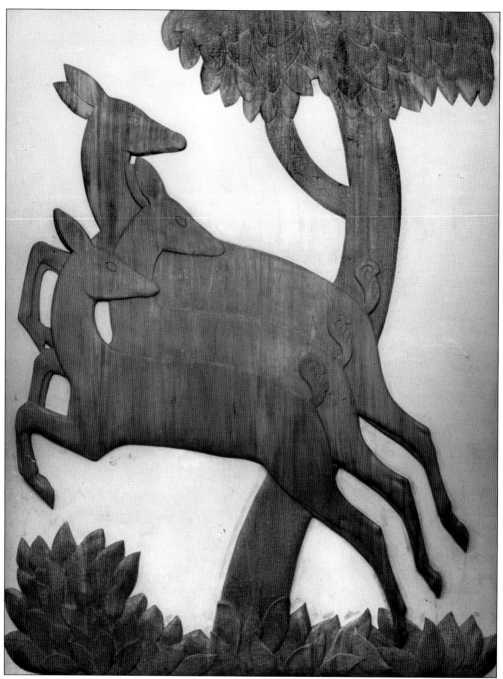

Remembered today as the first husband of celebrated abstract artist Barbara Hepworth, in his day John Skeaping was known primarily for his sculptures of animals. In his book *Animal Drawing*, Skeaping taught that most people cannot draw animals because most people do not know what animals really look like, stressing that an artist must be able to visualize forms. Although its current location is unknown, Skeaping's lovely gilded relief once decorated the Starboard Gallery. Supporting the ship's leitmotif of speed, the rhythm of the deer suits the *Queen Mary* and is the essence of Art Deco.

Edward Wadsworth's decision to become a painter was a disappointment to his family, who had planned to bring him into their worsted-spinning business. The family's factories did, however, provide him with a better understanding of machinery than that of his fellow Vorticists (an English art movement that combined elements of Futurism and Cubism). During World War I, Wadsworth was occupied with designing dazzle camouflage for ships. Far from blending in with the sea, dazzle camouflage made ships into large Cubist canvases to confuse U-boats about their size, direction, and speed. The *Aquitania* wore Wadsworth's design, making his murals for the *Queen Mary* quite modest in size, by comparison.

If a cat may look at a king, then certainly the one gazing calmly at passengers in the first class drawing room should feel at home aboard the *Queen Mary*, but it was an unusual subject for Kenneth Shoesmith. His twin passions were painting and the sea. "It was my craze for drawing ships that made me adopt the sea as a profession," he said, but that changed when his job as a ship's officer interfered with his painting. "The sea wouldn't spare me the time. So I had to give up the sea." When artists admired by critic Clive Bell had their work rejected, Bell wrote the following of the *Queen Mary*: "The managers, having voted recklessly for decoration, have been overtaken by terror lest they should be accused of a taste of art." Shoesmith shot back, " 'If the work doesn't suit the ship, alter the ship.' This, if not his words, is his attitude. Those who failed had their chance . . . the fault does not lie with those who gave them the chance."

Eight

FAMOUS PASSENGERS

The Duke and Duchess of Windsor were frequent passengers on the *Queen Mary*'s transatlantic crossings. The Duke of Windsor had taken a particular interest in the construction of the ship, whose maiden voyage took place during those few months he was king of England, and the Windsors always considered it to be their ship. Each time they sailed, the large, outbound suites reserved exclusively for them were redecorated, so carpets, paint, and curtains all reflected the Duchess of Windsor's favorite colors. The Windsors typically traveled with more than 120 pieces of luggage—not to mention their beloved pugs, who were also part of the entourage. Interestingly, the ex-husband of the Duchess of Windsor, Ernest Simpson, also found the *Queen Mary* to his liking, boarding the ship on December 1, 1937, to take his new bride, the former Mary Raffray, to England.

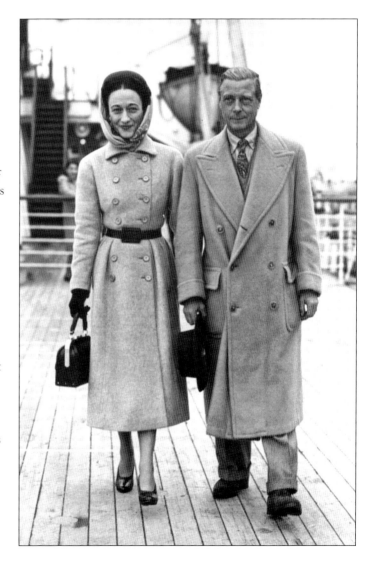

Winston Churchill was a frequent guest aboard the ship, both in peacetime and during World War II, when he sailed under the alias of "Colonel Warden." His tendency to fall asleep while smoking one of his ubiquitous cigars could have resulted in a disastrous shipboard fire, but it is said that a steward on one of the *Queens* contrived an effective solution. If Churchill fell asleep with his cigar still alight, it would roll down a fire-resistant chute into a bucket of water by his bed. In May 1943, while docked in New York, the ship's Main Deck was fitted with temporary offices for his delegation, and it was in his suite that he began making plans for Operation Overlord, also known as D-Day. His fondness for the *Queens* was evident in his postwar tribute. "The world owes a debt to these two great ships that will not be easy to measure. Vital decisions depended on their ability to continuously elude the enemy, and without their aid the final day of victory must unquestionably have been postponed."

Hordes of autograph hunters caused headaches for both celebrities and crew. In August 1937, Cunard ejected hundreds of fans swarming the liner in hopes of seeing Leslie Howard. It was primarily symbolic, since almost all returned within minutes. Most had given up by the time he arrived with his family just before departure, but three determined hold-outs waited outside his stateroom door—finally scurrying ashore mere moments before the gangplank lifted.

When Spencer Tracy arrived in London on the boat-train from the *Queen Mary*, fans rioted in what the press described as the Battle of Waterloo Station. Clark Gable's adieus to Nancy (Slim) Hawks prevented stevedores from lifting the gangplank on a 1948 departure. Nervous officials checked their watches, but even the fond farewells of the famous could not keep the ship from sailing on time—give or take a few minutes.

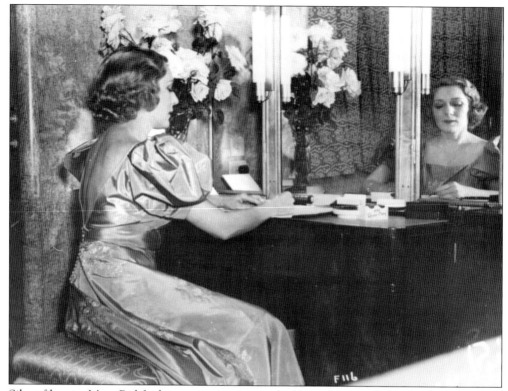

Silent film star Mary Pickford poses at a vanity on the *Queen Mary*, still lovely after more than a quarter century of stardom. At the height of her career, she could not appear on a ship's deck without a bodyguard on each side to protect her from fans. Her "America's Sweetheart" image led people to believe she was more approachable than most celebrities, but a hardheaded businesswoman lurked behind her innocent curls.

Actress Lili Damita was better known for the men she married than her acting career. The cosmopolitan French beauty met her second husband, Errol Flynn, on a transatlantic sailing. The Flynns had a legendarily tempestuous union that resulted in one son, the photojournalist Sean Flynn, who disappeared mysteriously in 1970 in Cambodia, at the height of the Vietnam War. Damita, who married twice more, was fluent in five languages.

Ruth Gordon departed for England aboard the RMS *Queen Mary* in early September of 1936 to appear in the play *The Country Wife* at the Old Vic in London. Although placed under contract in Hollywood in the early 1930s, she did not make her first film until 1940. The Massachusetts-born Gordon was no stranger to the ocean—her father had been a sea captain.

Anna May Wong was the first Chinese American movie star. Born in Los Angeles, she began acting in silent films at an early age. Wong left for Europe in the late 1920s because she found the stereotypical roles she was offered demeaning. Known as "The World's Most Beautiful Chinese Girl," during the 1930s she traveled regularly between the United States and Europe, and starred with Lawrence Olivier on stage in London.

It is said that Marlene Dietrich was never seen at breakfast aboard a ship and only occasionally at lunch, but when she appeared, her entrance always achieved maximum glamour. On August 1, 1939, as war brewed on the horizon, the star returned to the United States aboard the *Queen Mary* from a two-month vacation in London, Paris, and the South of France to begin work on *Destry Rides Again* with Jimmy Stewart.

It is hard to say which figured more often in gossip columns, news about actress Dolores del Rio's dogs or a snippet saying she was embarking on the *Queen Mary*. She seemed to always have dogs with her, most famously her highly pedigreed bull terriers. In 1935, she paid a record price of $5,000 for Faultless of Blighty, a.k.a. Bonnie. Silversea of Brighton is pictured with her here.

It was probably not when this delightful picture was taken, but in 1945 actor David Niven returned to Hollywood via the *Queen Mary* to resume his film career after World War II. He had been one of the first actors to go back to England to join the army after war was declared, and he was awarded the American Legion of Merit, the highest American order that can be earned by a foreigner.

In 1936, a story made the rounds that Fred Astaire tap-danced on a guardrail for reporters on an ocean liner, and ships set the scene in several of his movies, but did he ever dance on the *Queen Mary*? With wounded soldiers aboard, Bob Hope had this to report: "Fred danced through all the wards for two and one-half hours steady. When he got through, he had to have his feet half-soled."

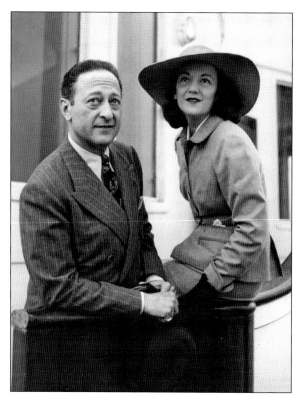

Violin virtuoso Jascha Heifetz and his second wife, Frances, met and married in 1947 in California. Heifetz was on a performing sabbatical, and she had relocated following her divorce from William Guggenheim Jr., grandson of banking baron Isaac Guggenheim. Known as a great beauty, Frances and Heifetz had one son together, and they were divorced in 1962. Heifetz's first wife was silent screen actress Florence Vidor, the ex-wife of King Vidor.

Yehudi Menuhin sailed on the *Queen Mary* both with his first wife, heiress Nola Nicholas, and his second wife, ballerina Diana Gould, whom the great dancer Pavlova called "the only English dancer with a soul." The violin virtuoso traveled constantly throughout his career. He performed for Allied soldiers during World War II and for prisoners of the Bergen-Belsen concentration camp after its liberation. After becoming a British citizen, he was knighted in 1985.

The Olympic gold medal swimmer, Hollywood actor, and famously kindhearted man Johnny Weissmuller was a hit with both passengers and crew aboard the ship. In an interview for the Southampton Port Cities Oral History project, a former bellboy recalled how the famous *Tarzan* actor thrilled the ship's bellboys by joining them after hours in the first class pool for a swim. "So he come down dressed in his trunks, and it's in the winter and of course the ship's rolling. I mean one minute there's no water at all and the next minute it's . . . and he just dived right off the balcony. Of course all us kids . . . 'that's Tarzan you know', so we all jumped on him and he's throwing us all over the place and picking us up. And he used to come there every night religiously then like and have a swim with us."

Dame Anna Neagle was one of Great Britain's most popular actresses during the 1930s and 1940s. Noted for her beauty, she began as a dancer but was soon discovered by her future husband, director/producer Herbert Wilcox. In 1937, she portrayed Queen Victoria in a pair of biopics produced by Wilcox, which proved popular enough that the couple was called to Hollywood, remaining until 1943, when they returned to England.

After seeing Sonja Henie win a championship in 1928, Cecilia Colledge's mother worked with skating coaches, and even a circus contortionist, to mold her daughter into an elite figure skater. Cecilia was 11 when she first skated against Henie. She later became the first woman to execute a double rotation jump in competition and was credited with inventing the camel and layback spins, and the one-footed axel jump.

An early aviator and paratrooper, the Black Eagle of Harlem, who rose to fame parachuting as a saxophone-playing devil, lived flamboyantly. When Col. Hubert Fauntleroy Julian performed a jump at Haile Selassie's coronation ceremony, he landed at the Ethiopian emperor's feet, but later crashed Selassie's personal airplane into a eucalyptus. In 1949, Julian became a licensed arms dealer, earning large amounts of cash and FBI surveillance. He died at 86 of natural causes.

From left to right, Robert Montgomery, Loretta Young, Bob Hope, Alexis Smith, and Craig Stevens were bound for London in 1947 for a command performance while Britain was buzzing about Princess Elizabeth's wedding. Hope joked, "If everybody who says he's been invited to the wedding attends, England will have to take back India and hold it there," and that crowds may force Mountbatten "to say 'I do' by telephone."

Bob Hope's numerous crossings on the *Queen Mary* frequently provided fodder for his syndicated column, "It Says Here." He described a wartime crossing as so rough "you would think Hitler was hiding in the hold and they were trying to shake him loose." After a performance, he added, "It's hard to lose any kind of audience onboard ship. You can follow them right into their cabins." His shipboard quips were picked up by other columnists, too. Hedda Hopper loved Hope's crack about "women and children first" in an emergency: "Could I help it if it was dark and I had to show them the way during drill?" May Mann quoted his new lyrics for "Thanks for the Memories," "*Queen Mary*, thanks for the memory. Some folks slept on the floor, some in the corridor; but I was more exclusive, my room had 'gents' above the door." Hope was uncharacteristically serious after the radio broadcast of England's declaration of war in the ship's salon. While passengers spontaneously sang "God Save the King," he muttered, "and the *Queen Mary*."

Nine

FINAL VOYAGE

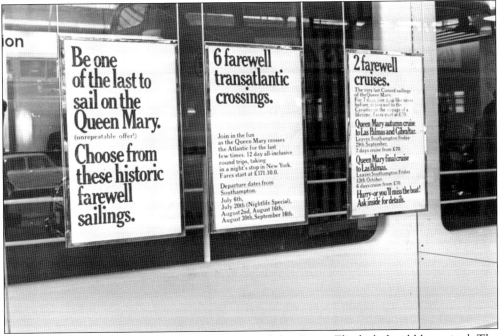

In 1967, Cunard decided that the *Queen Mary* and the *Queen Elizabeth* should be retired. The offers they received ranged from the sensible to the ridiculous. The award for the most bizarre belonged to a landlocked man who proposed joining the two *Queens* together into the world's largest catamaran. Long Beach won the bidding for the *Queen Mary*, partially due to the depth of the harbor. With $3,444,000 from local Tideland Funds, Long Beach business owners, community leaders, and elected officials edged out Philadelphia by only $50,000. New York was disappointed that its plan for a floating school failed. By summer, the crown jewel of the legendary Cunard ocean liners began preparations for a new career as a museum and hotel in sunny California. Against the wishes of Cunard, the City of Long Beach sold tickets for the final cruise. It made financial sense, as it would have cost more than $600,000 to bring the ship over empty. Although the *Queen Mary* was not in prime condition by then, sentiment filled her staterooms. Passengers were overwhelmingly Americans over 65, mostly from Southern California.

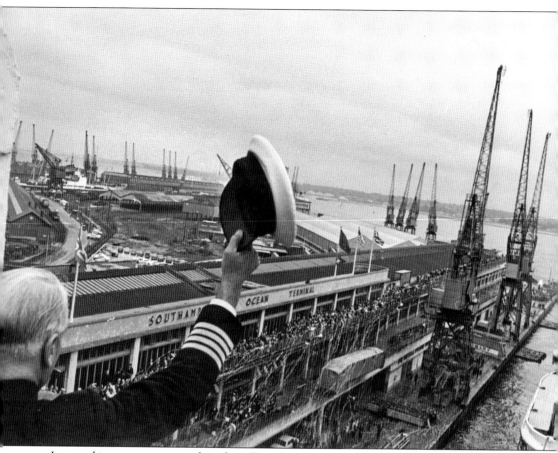

It was a bittersweet autumn day when Capt. Treasure Jones waved good-bye to Southampton as the *Queen Mary* began her final voyage. After 47 years at sea, it was his last voyage as captain. Cunard had a mandatory retirement age of 63. Although he looked forward to gardening and golfing, it would be a different life for him. He told the *Los Angeles Times* that he was sad, "but we've never been around the Horn and up the west coast of South America, so it's a fine last voyage for both of us." He expressed pleasure that she was going to Long Beach, "where she may stand as a monument to British shipbuilding." He also approved of California's weather, saying it would be easy to keep her beautiful there. Mostly he was happy that she would not be sold for scrap, which would have been a tragic end for a beautiful lady. It had been his sad task to take the *Mauritania* for demolition, saying, "I felt so bad I never turned around for a last look at her." Many grateful ship-lovers shared his relief that the same fate did not await the *Queen Mary*.

The final passage was a never-ending whirl of galas, all-night dancing, and autographs. For the first time, all three classes intermingled. Costumes depicting the ship were obviously de rigueur at the fancy headdress contest. All the gaiety could not hide the mixed emotions of the crew, however, or that the *Queen* was badly in need of repairs, but most passengers were happy to be part of such a momentous occasion.

Care was taken that sirens and whistles would play only low notes to avoid a disturbingly shrill tone, but a nearly 7-foot-tall, one-ton, steam-powered whistle that could be heard for 15 miles cannot quite be made into a pleasant noise for passengers. Long Beach turned down several requests to purchase the whistle, including one from University of Washington students who wanted to blast it at football games.

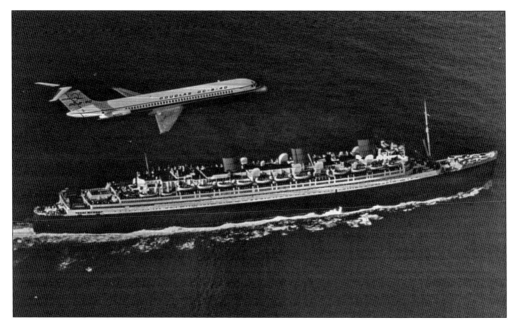

On the penultimate day of the journey, a DC-9 built in Long Beach jettisoned thousands of red and white carnations over the *Queen Mary*. Writer Malcolm Epley praised the aim of the blossom bombardiers. Flowers floated onto the deck, he reported, although a stiff breeze blew some into the water on the port side. With the blossoms delivered, the airplane made a final wing-wagging salute and turned for home.

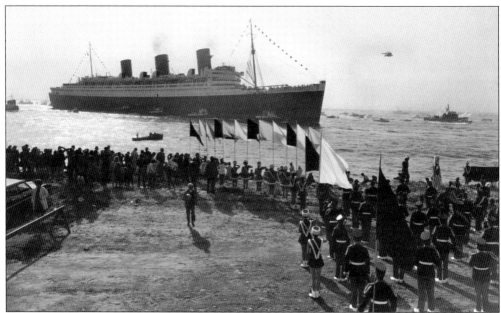

At least one passenger and nine crew members experienced the first and last voyages. In 1936, Kenneth P. Behr took the *Hindenberg* to Frankfurt on a whim, then went on to England, where he boarded the new superliner. For sentimental reasons, he decided to take the final voyage, as well. When asked how the first voyage differed from the last, Behr sniffed, "In those days, even the people in third class wore tails."

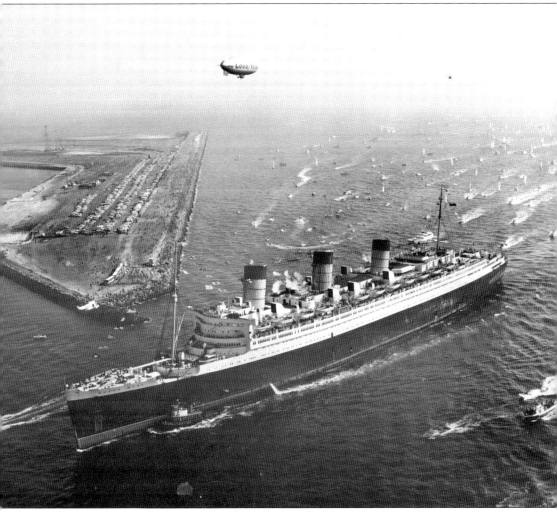

An armada of smaller vessels met the *Queen Mary* as she pulled into Long Beach. Fireboats sprayed fountains of water, the blimp floated overhead, and multitudes of small boats darted around their new *Queen*. The *Independent Press Telegram* reported that her entourage included every variety of watercraft, from nuclear cruiser to a small pink kayak. A skywriter etched "Hail to the Queen" against the sky. Her size astonished people. Bob Wells, the director of publications and public information for California State College at Long Beach, took one look at her and suggested, "We oughta abandon this museum idea and just make her the fifty-first state." The ceremony turning her over to the City of Long Beach was more solemn. Captain Jones fought tears as he recalled the sadness of his countrymen when the *Queen Mary* left. Including servicemen, he noted, she probably carried more Americans than Britons. "If she couldn't be in Britain," he added, "this is the place for her—her second home—America."

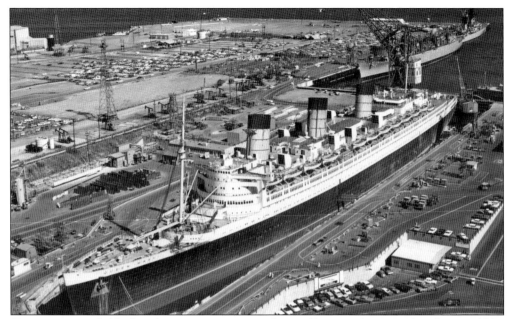

Controversy swirled before the conversion process began. Because she was a ship that would be permanently moored, both maritime and land-based unions claimed jurisdiction. The U.S. Navy refused permission to use their drydock until the issue was resolved. A superior court order, coupled with intervention by Secretary of the Navy Paul Ignatius, finally allowed the *Queen Mary* to make the trip to Terminal Island, where her hull was sandblasted and repainted.

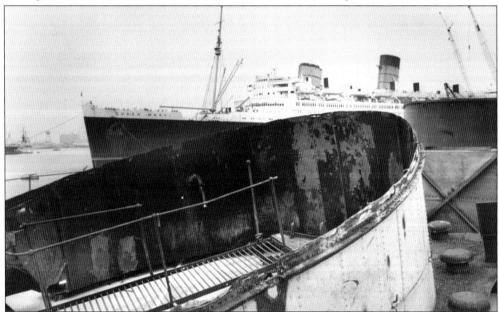

Work continued after she left drydock. Smokestacks were detached to facilitate pulling out the machinery that kept her running. Engines and boilers were removed. Although the first class staterooms were left mostly intact, second and third were reconfigured and removed. Public rooms served new purposes or were eliminated entirely. She slowly changed from a seaworthy vessel to a hotel and museum.

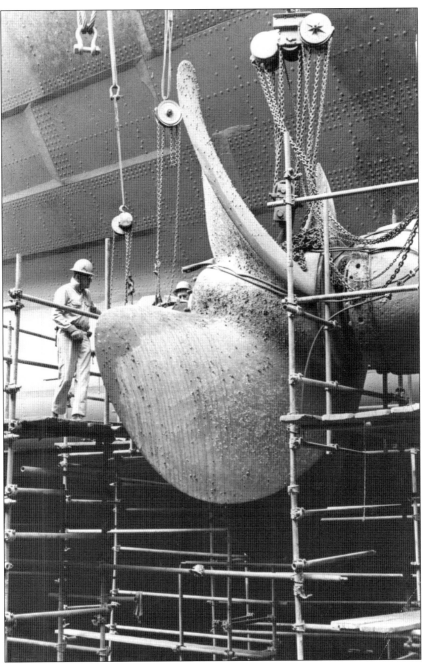

Part of the agreement with Cunard stipulated the *Queen Mary* be converted in a way that rendered her no longer seaworthy. While she was in drydock, three of her 35-ton bronze propellers were removed. Plans were made at that time to encase the last propeller in a huge chamber made of steel and glass, so visitors could watch it turn slowly. Museum directors had to make a decision when it was discovered that the propeller they had chosen to keep was missing the cone-shaped cap that seamen called the dunce cap. It has been lost in a near-disaster near Cherbourg, when the ship had to be thrown into reverse to avoid a fleet of fishing boats that had wandered into the shipping lane.

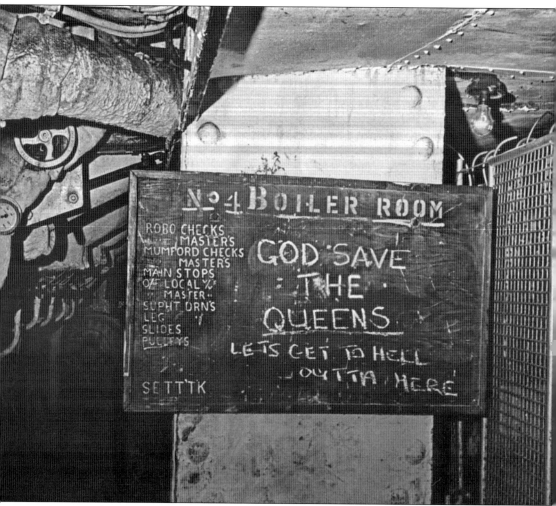

Everyone had an opinion on the ship's final berth in Long Beach. Helen Hayes joked to Cecil Smith, "If they wanted a venerable relic, they could have gotten me cheaper." She added this as she plunged into a swimming pool: "In the water I remind people of the *Queen Mary*." Perhaps the final word on the *Queen Mary* was scrawled by a crew member in the No. 4 boiler room: "God save the *Queens*, let's get to hell outta here." Of all the great ocean liners of the grand travel era, there is only one left. Perhaps an updated version of the crew's graffiti should read, "God save the *Queen Mary*. Let's keep her here forever."

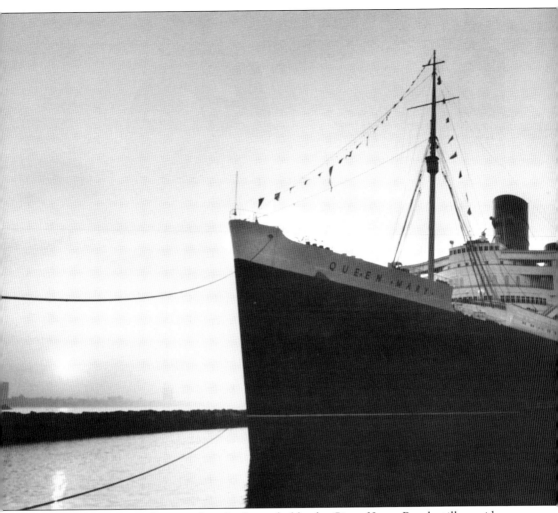

Although no one can say for sure what the future holds, the City of Long Beach still considers the *Queen Mary* a leading tourist destination. At press time, the city council is working on a comprehensive master plan for preservation, which will include an inventory of original historic artifacts and archives aboard. A new leaseholder will be responsible for day-to-day operations, but ultimately the *Queen Mary* belongs to the citizens of Long Beach, and, by extension, all who love ships, beauty, and history. Perhaps one day she will be burnished back to her original luster. The *Queen Mary* may be permanently in port, but she still allows her passengers to dream of a time when elegance sailed the seas.

www.arcadiapublishing.com

Discover books about the town where you grew up, the cities where your friends and families live, the town where your parents met, or even that retirement spot you've been dreaming about. Our Web site provides history lovers with exclusive deals, advanced notification about new titles, e-mail alerts of author events, and much more.

MADE IN THE USA

Arcadia Publishing, the leading local history publisher in the United States, is committed to making history accessible and meaningful through publishing books that celebrate and preserve the heritage of America's people and places. Consistent with our mission to preserve history on a local level, this book was printed in South Carolina on American-made paper and manufactured entirely in the United States.

This book carries the accredited Forest Stewardship Council (FSC) label and is printed on 100 percent FSC-certified paper. Products carrying the FSC label are independently certified to assure consumers that they come from forests that are managed to meet the social, economic, and ecological needs of present and future generations.

FSC
Mixed Sources
Product group from well-managed forests and other controlled sources

Cert no. SW-COC-001530
www.fsc.org
© 1996 Forest Stewardship Council

Find Your Place in History.